To Jen,

Duluth, the place of your birth —

Nadine Blacklock —

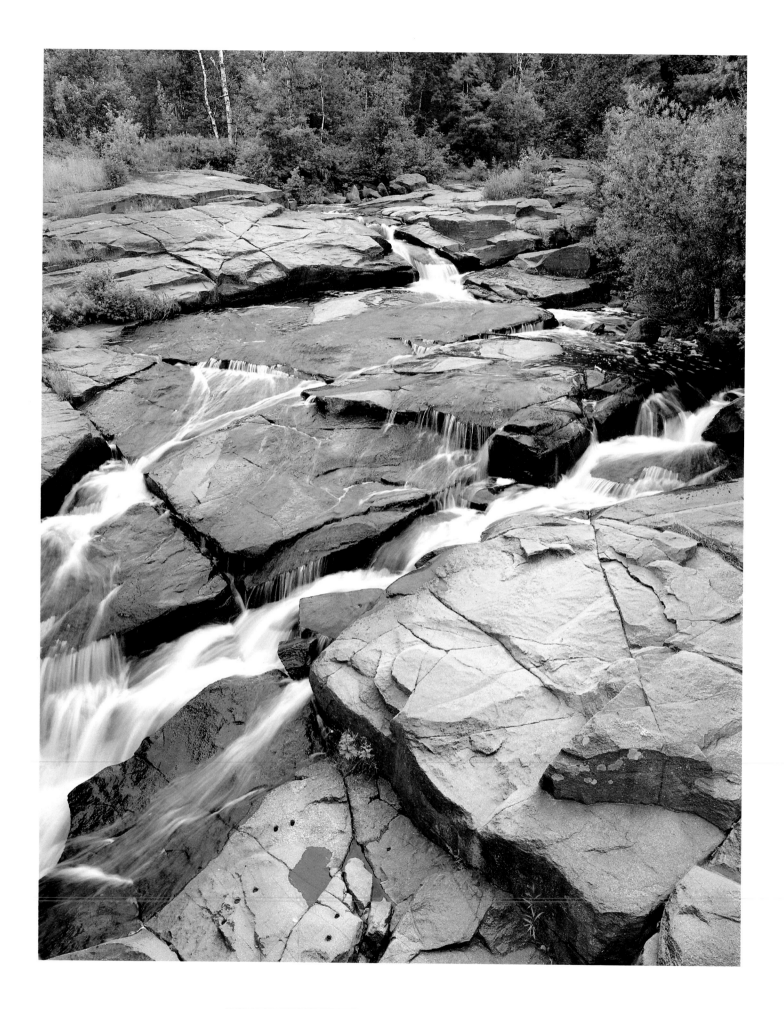

Kingsbury Creek, Fairmont Park

CRAIG ❧ NADINE
BLACKLOCK

THE DULUTH
PORTFOLIO

Pfeifer-Hamilton
Duluth Minnesota

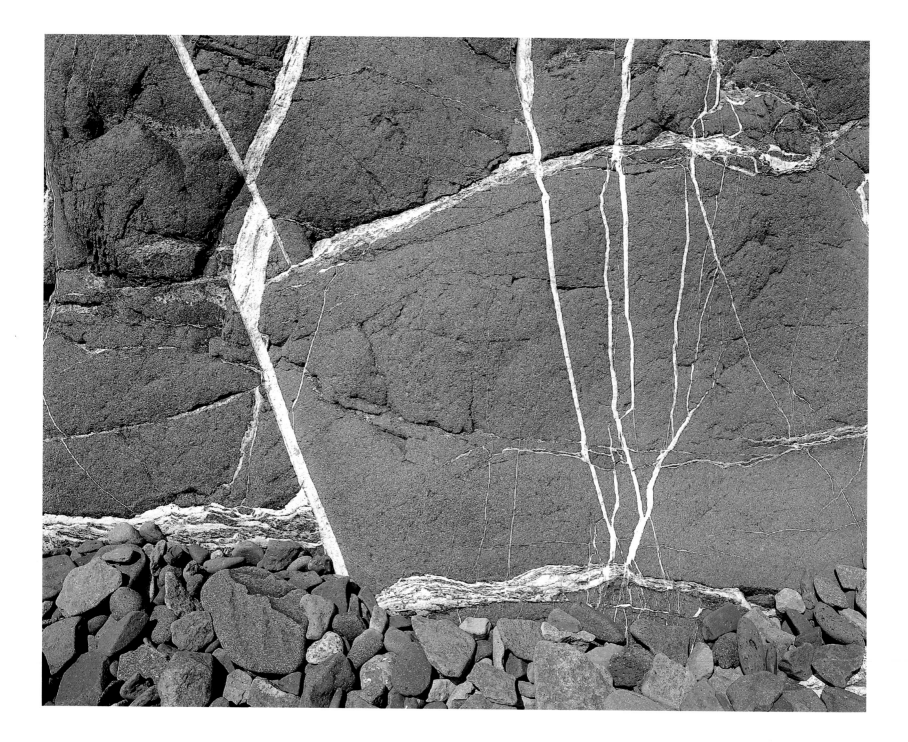

Calcite veins in basalt dike on North Shore of Lake Superior

INTRODUCTION

It would be worth the while if in each town there were a committee appointed to see that the beauty of the town received no detriment. If we should have the largest boulder in the county, then it should not belong to an individual, nor be made into doorstops.

Thoreau *Journal*, January 3, 1861

Throughout history, visual artists have sought to capture the mysterious beauty of their natural surroundings. Nineteenth century American landscape painter Thomas Cole, for instance, portrayed the American wilderness as a sublime and sacred place; a sanctuary of purification and transcendence. In his hands, the wilderness landscape became a moral statement, the allegorical equivalent of biblical Eden, vulnerable to predation by the odious serpent of civilization. Cole foresaw industrialization draining the aesthetic and spiritual existence from humanity. Writers of the time such as Ralph Waldo Emerson and Henry David Thoreau were also cynical about the progress of civilization. Thoreau extolled nature's virtues and immersed himself in a contemplative life among quiet forests and meandering streams. Emerson envisioned factories, with their numbing mechanical sameness, destroying the perfect spirituality found in nature.

One hundred years later, American photographer Ansel Adams responded to the emptiness of the Industrial Age by focusing his camera on the western landscape and finding inspiration in the grand scale of the natural world. The tremendous popularity of his Yosemite National Park images awakened the nation to its wilderness heritage and helped establish the genre of nature photography.

Craig and Nadine Blacklock, like American landscape painters and nature photographers of the past, share a love of nature and an abiding concern for the preservation of wilderness areas. Seemingly informal compositions of impeccable detail attest to the Blacklocks' finely tuned aesthetic sensibilities and within the illusionistic confines of the picture plane create an authentic expression of these gifted photographers' daily lives.

The Blacklocks, including Craig's father, Les, have produced several books of color photographs interpreting Minnesota's natural splendor. The photographs presented in this volume document many of Duluth's parks and green spaces, offering an evocative look at one of Minnesota's most beautiful cities. It is readily apparent from these breathtaking images that Duluth's rugged terrain and intimately scaled urban environment still possess a wilderness heart and, with it, the power to inspire. Is there anyone who has seen the panorama of St. Louis Bay from atop Thompson Hill, viewed Lake Superior from Hawk Ridge, walked through Hartley Park, or dawdled along the banks of Tischer Creek who has not felt blessed by the experience? It is my hope that these poignant Blacklock photographs will not only commemorate Duluth's natural history, but will also focus our collective attention on the significance of public landscapes and on the necessity of preserving the natural environment.

—John F. Steffl, *Visual Artist, Curator, and Artistic Director of the Duluth Art Institute*

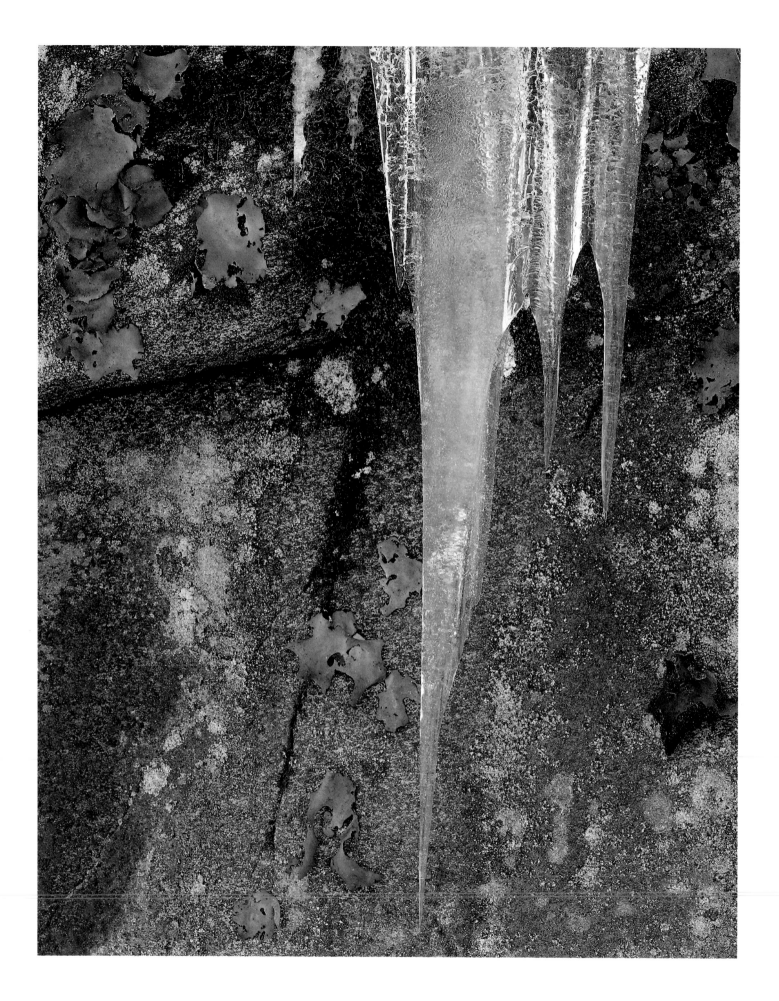

Icicle, lichens, and moss, Bardon Peak Park

PREFACE

Many visitors know Duluth as an industrial port city. They observe its interesting architecture and bridges, stroll through its splendid rose garden, and take museum tours to learn about the maritime history of Lake Superior.

If this is all they see of Duluth, they are missing the city's greatest asset: its natural beauty. Within Duluth's city limits there are forests, waterfalls, and shorelines rivaling any in the state's true wilderness areas. Duluth's forest preserves and parks protect more than 11,000 acres. That's approximately the same area as Cascade River, Gooseberry Falls, Judge C. R. Magney, and Split Rock Lighthouse state parks on the North Shore, combined!

Duluth is rare in this abundance of green space. Few cities have such a history of integrating nature into their urban environment. In the late 1880s William K. Rogers, president of the city's first park board, envisioned a hilltop parkway (now Skyline Parkway) connected to lakefront parks via woods bordering several creeks. While the lakefront parks were not fully realized, much of his plan did become a reality.

Duluth owes much to several early citizens who generously gave their time, money, and land to establish parklands throughout the city—people like Mayor Clarence R. Magney, Mayor Samuel F. Snively, Chester A. Congdon, Julia Marshall, Caroline Marshall, and Mrs. E. C. Congdon. Today, Duluth's greenbelt stretches from Fond du Lac's wild forests, across the top of the city along Skyline Parkway, down to the shore, to several miles up the shore beyond Lester River. Almost every neighborhood in Duluth is within an easy walk of a public park.

A 1974 publication prepared by the Duluth Department of Research and Planning begins:
Very simply, open space is not closed space . . . it is the counterpart of development. Specifically, open space serves the urban functions of providing park and recreation opportunities, protecting valuable natural resources, and structuring urban development. The significance of open space . . . is also felt in terms of privacy and insulation, the feeling of spaciousness it imparts, and its ability to increase our perception of the scope of things. Thus, psychological values are gained through open space which are difficult to measure but without which we would have a far less livable environment.

By this criterion, Duluthians enjoy a most livable environment. Yet development pressures continue. Remaining parcels of wooded land are viewed by some as places for new malls or housing developments. It will take a vigilant citizenry and long-range thinking by politicians to ensure Duluth retains its unique natural places.

We dedicate this collection of photographs to those who had the foresight to establish these park lands, and to those who have protected them.

ST. LOUIS RIVER

I am making meager headway kayaking against the increasingly swift current in the St. Louis River upstream from Fond du Lac. A look back at recent geological history explains why my paddle, up until now, had been so easy. During the last glaciation, the ice mass depressed the land for hundreds of miles to the northeast. When the ice melted, the land rebounded, tilting the Lake Superior basin and raising the water level in the western part of the lake. The St. Louis River was submerged as far as Fond du Lac, creating an estuary along what geologists refer to as a drowned river.

This estuary provides excellent fish and wildlife habitat. While the water quality has improved dramatically in recent years, the river still carries industrial pollutants from past decades, creating concern about eating fish caught in the river. Some non-native plants and fish have been introduced into the river's ecosystem and now dominate indigenous species. The St. Louis River System Remedial Action Plan identified such problems. Solutions are now being discussed and implemented in both Minnesota and Wisconsin. One sign of success is the return of saturated oxygen levels at the bottom of St. Louis Bay.

Above Fond du Lac, the river changes abruptly to a narrow waterway bound by steep banks. Today blinding-white thunderheads make silhouettes of ridge-top pines. Below the pines, white cedars cling to a cliff face. I continue paddling as far as the hydroelectric dam. Here, red sandstone walls constrain the outside curves of the river. The layered, sedimentary rock was formed over a billion years ago by sand and silt flowing into a broad lowland situated appoximately where Lake Superior is now.

Upstream of the dam, whitewater tumbles over jagged slate in Jay Cooke State Park. This natural barrier to water travel created the need for the six-and-one-half-mile Grand Portage of the St. Louis (different from the Grand Portage at the northeast corner of Minnesota), used by Anishinaabeg and Voyageurs to reach inland rivers and lakes. For decades, the town site of Fond du Lac served the function Duluth currently does: the port at the head of the lakes.

I swing the kayak around and speed downstream to my camp, making it to the tent just as raindrops begin plopping into the river. The concentric patterns on the water remind me of the lily pads I had previously photographed. I'd been walking along the bridge to Oliver, Wisconsin, trying to find a perspective showing the shape and expanse of the river's lower reaches when I came upon acres of lily pads—green disks against black water. The river channel cut a classic "S" through the slough, beyond which stood Duluth's hills—gray and far-away. —CB

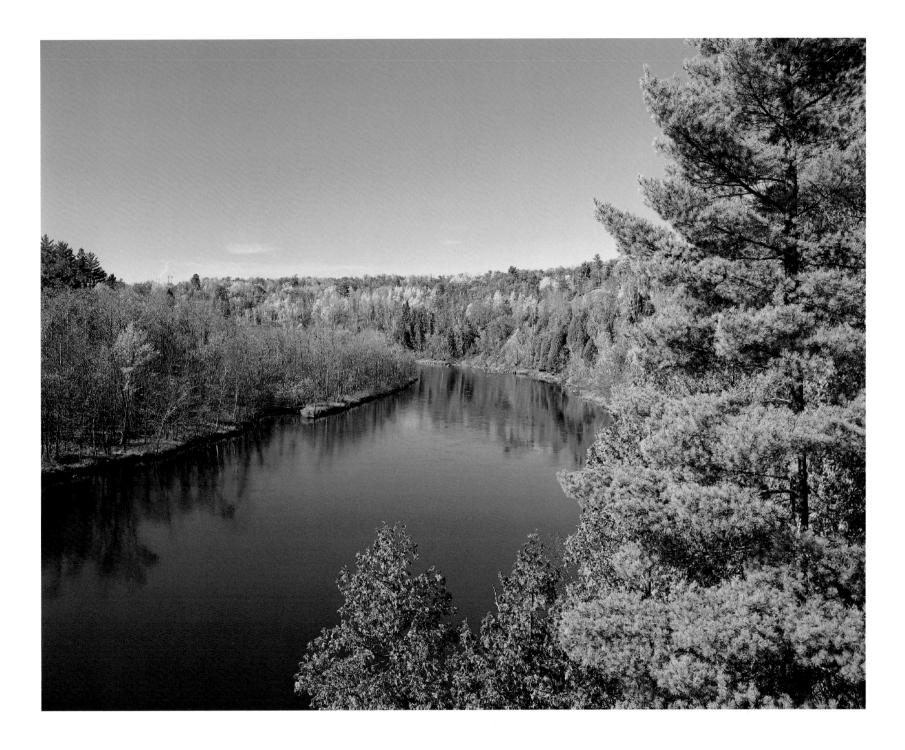

St. Louis River, Fond du Lac Park

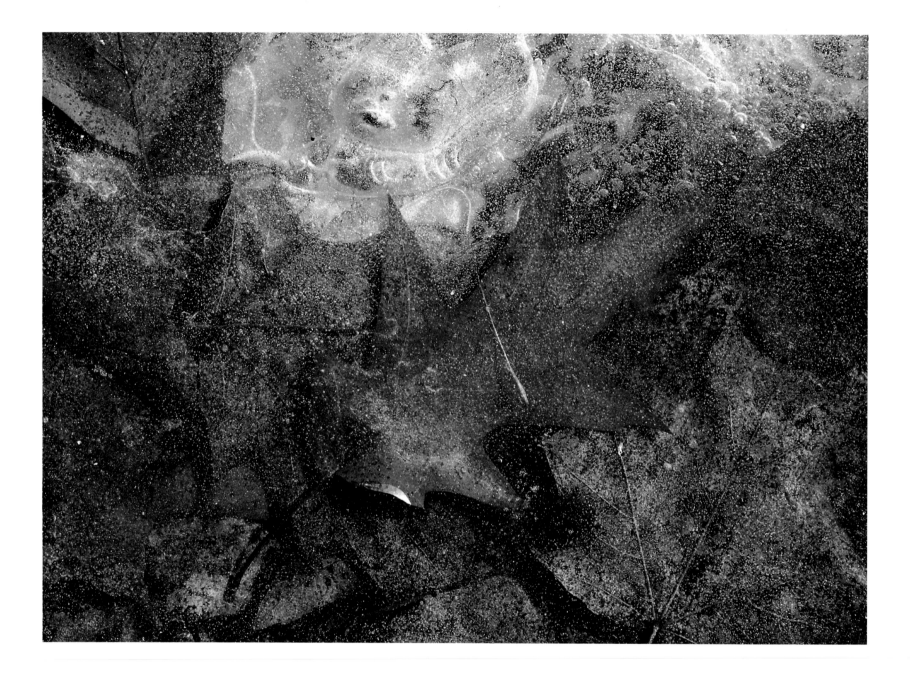

Red oak leaf in ice

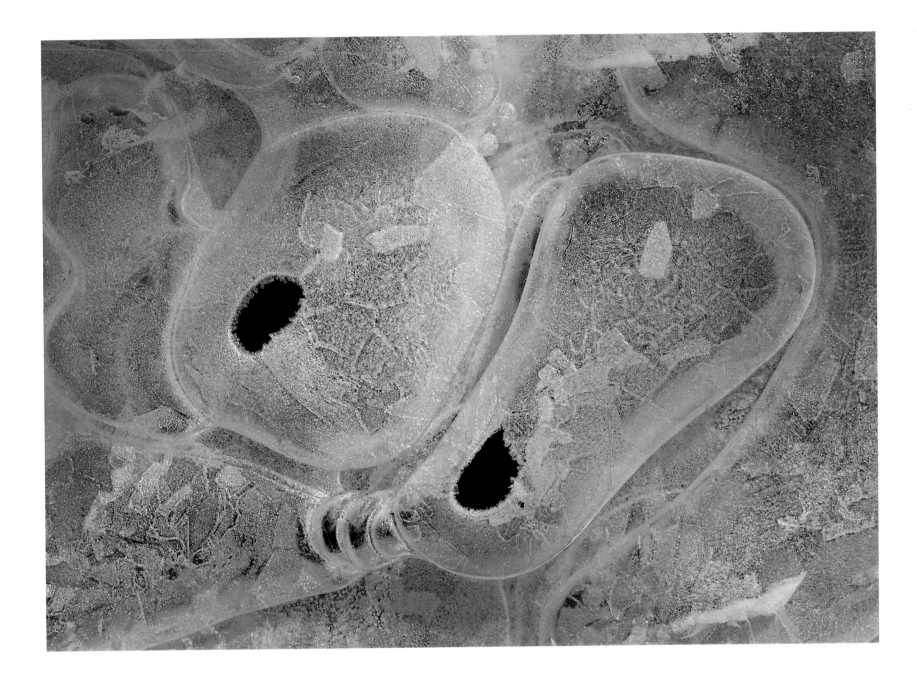

Bubbles in ice

Beds of arrowhead line much of the shore along the lower reaches of the St. Louis River. The starchy tubers of the duck potato or "wapato," were eaten by Native Americans and early settlers fresh, steamed, or dried for winter use and pounded into flour. Waterfowl and muskrats also eat them.

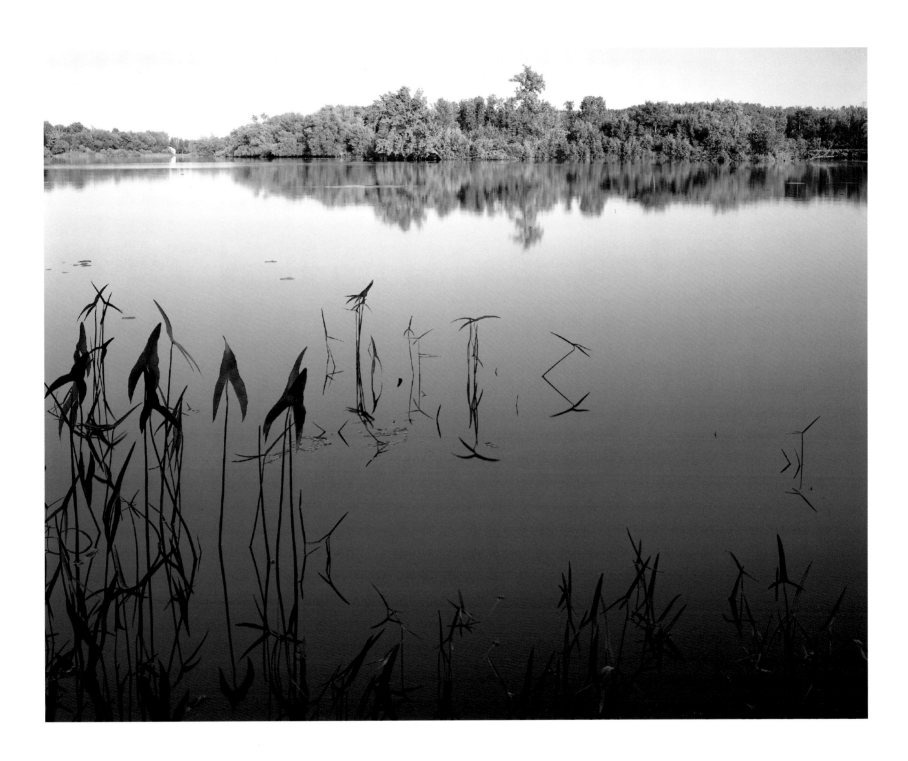

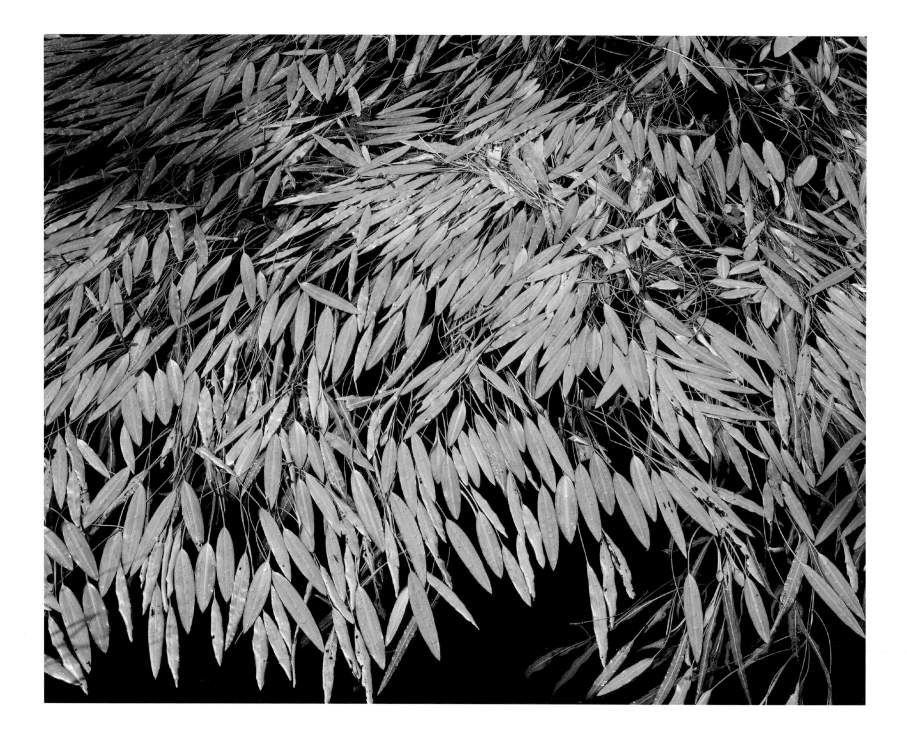

Swamp smartweed

Red pine trunk and white cedar, Fond du Lac Park

Winter's soft, sometimes somber palette surrounds us for half of each year, yet the colors are seldom noticed or appreciated. In summer, set against vibrant blues and greens, these birches on the bank of the St. Louis River would be perceived as white. Snowy surroundings allow the warm hues of their trunks to stand out in this winter landscape.

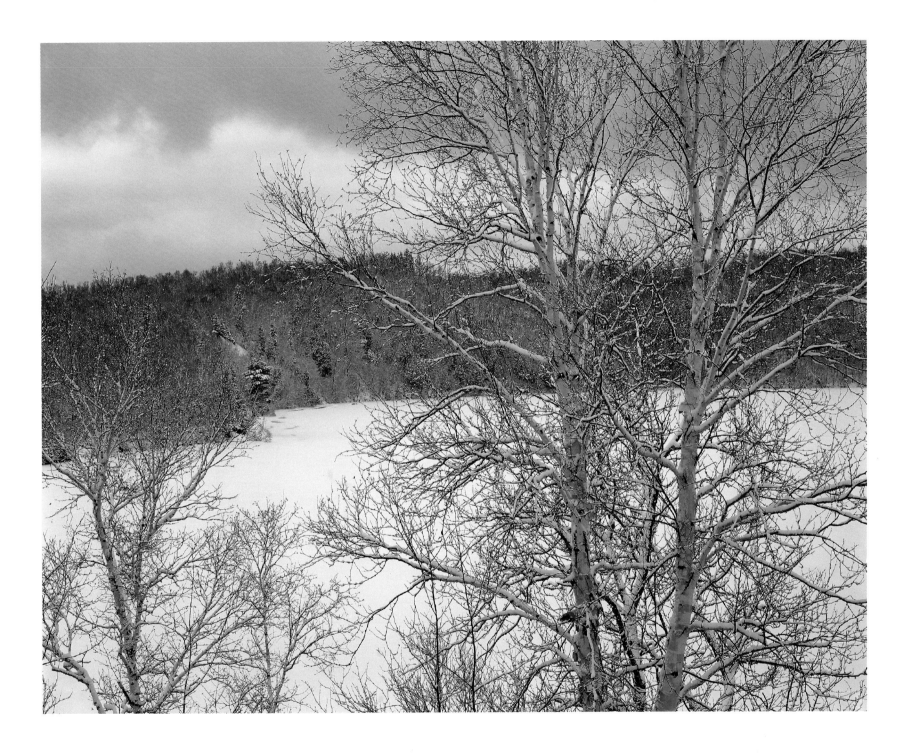

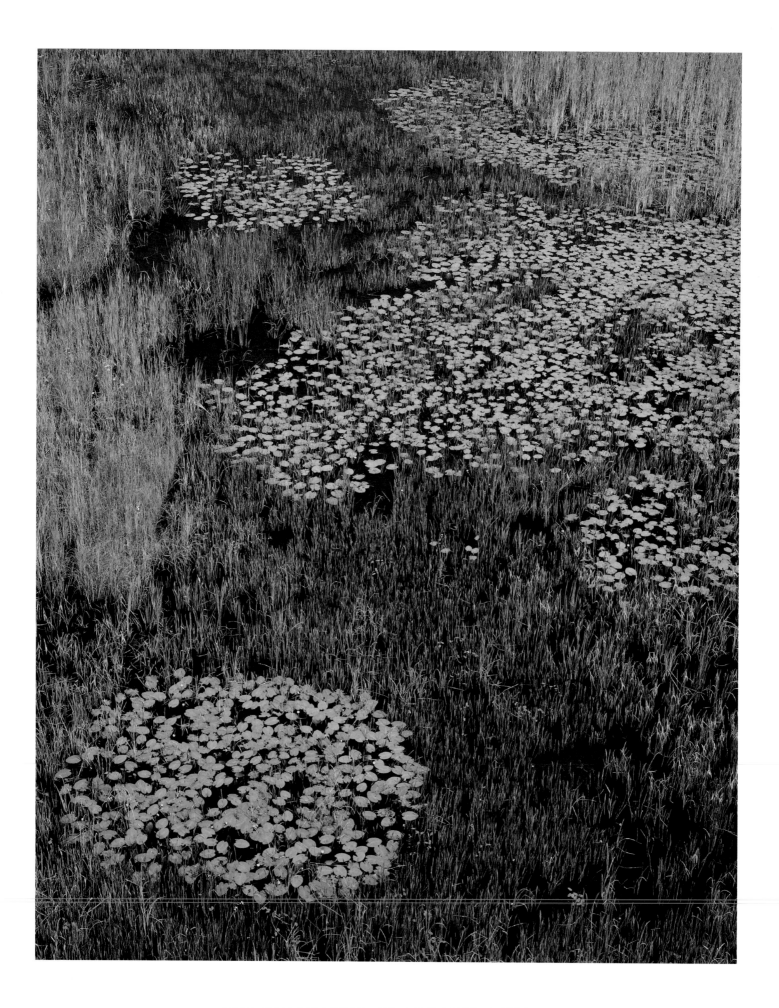

Yellow pond lilies, arrowhead, and cattails

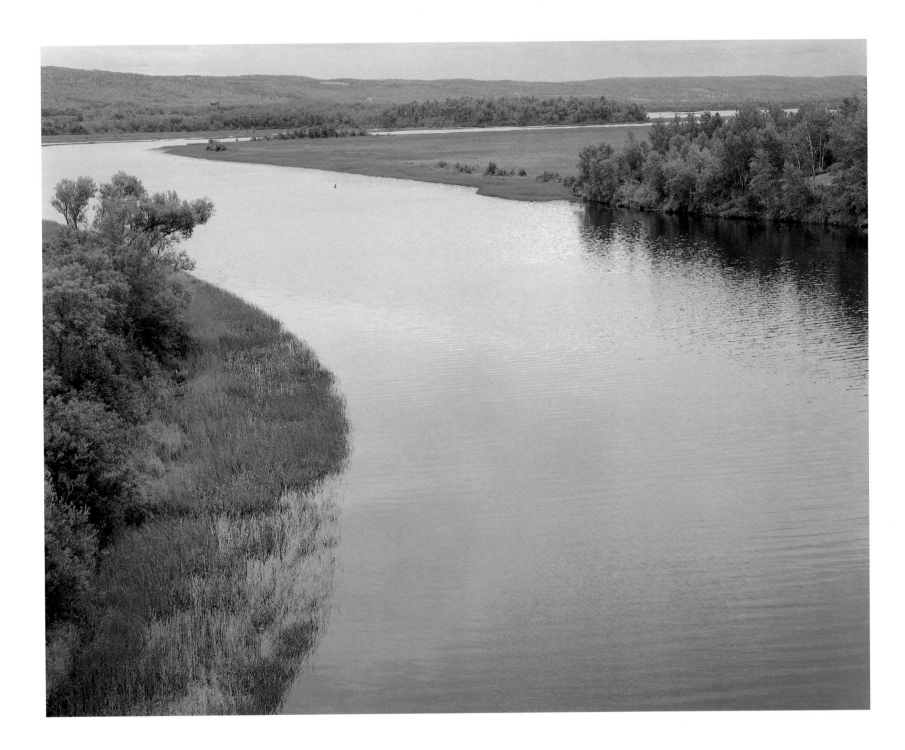

The "drowned," lower reaches of the St. Louis River

WOODLANDS

Dark clouds close the sky, snuffing out spots of sunlight on the autumn foliage. Ely's Peak dissolves behind a curtain of rain. The storm crosses a valley and reaches my position on an outcrop of Bardon Peak. I drink in the solitude, raising my face to let the first raindrops wet my cheeks. These peaks were special to the Anishinaabeg. Ely's Peak was a fasting site for young men seeking visions. Bardon Peak, called *Manidoowi-aazhibik* or "Spirit Mountain," was thought to be home to the mythological character *Wenaboozhoo*. Today seems a good day for seeking visions and communing with spirits.

Bardon Peak lies at the southwestern extent of the Duluth Gabbro Complex, an igneous rock formation reaching almost to the Canadian border. Much of this gabbro ridge supports a northern hardwood forest of maple, oak, basswood, yellow birch, and ash, augmented with paper birch, aspen, white spruce, red pine, white pine, balsam fir, and white cedar.

Starting in the 1850s, lumbering dramatically altered Duluth's forests. By 1924 most of the big pine trees had been felled and 7.75 billion board feet of lumber had been shipped out of Duluth. Fires often followed logging, giving rise to forests of uniform-aged birch trees or open hillsides of grass and sumac. In some areas second-growth stands of pine are now reaching maturity.

Duluth's patchwork of deciduous and coniferous, young and mature, forests provides diverse ground cover. Flowers typical of both the central Minnesota hardwood forest and the northern boreal forest flourish in the city. The most spectacular display comes in mid-May, when large-flowered trilliums turn the woods surrounding Spirit Mountain snowy-white, and the ash swamps fill with marsh marigolds. Look closely and you will find many smaller flowers: spring beauty, wild oats, trout lily, wood anemone, and large-flowered bellworts rising through bleached maple and oak leaves. Walk on the spongy, fragrant duff beneath pines and you will discover beds of bunchberry flowers, twinflower, and starflower. In summer, fungi in a variety of forms and hues will supplant the wildflowers on the forest floor.

Nearly all species of northern Minnesotan wildlife are found in Duluth. Large mammals like deer, bear, coyote, and red fox are common in the city's forests. Their presence proves that if habitat is preserved, many creatures can live in close proximity to people. In order to keep this habitat intact, the city and its inhabitants need to choose stability, rather than growth, as a long-term goal.

As I look out at a wealth of trees from my rock on Bardon Peak, it is easy to see how we once thought of the world's resources as limitless. Looking closer around me at charred pine stumps, I am reminded how illusory that vision was. —CB

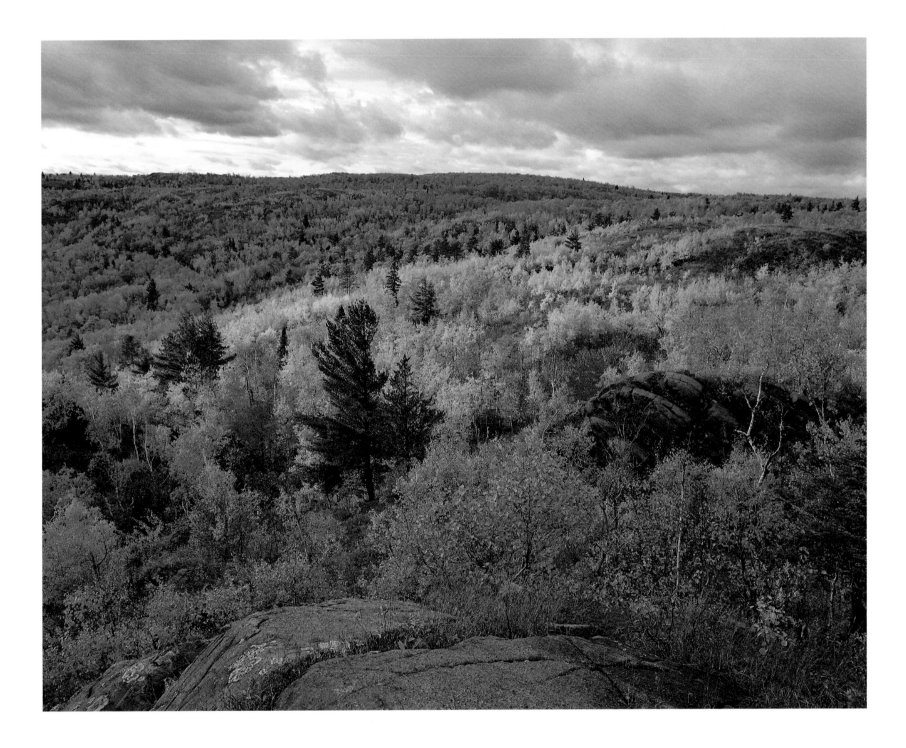

Mixed forest, Bardon Peak Park

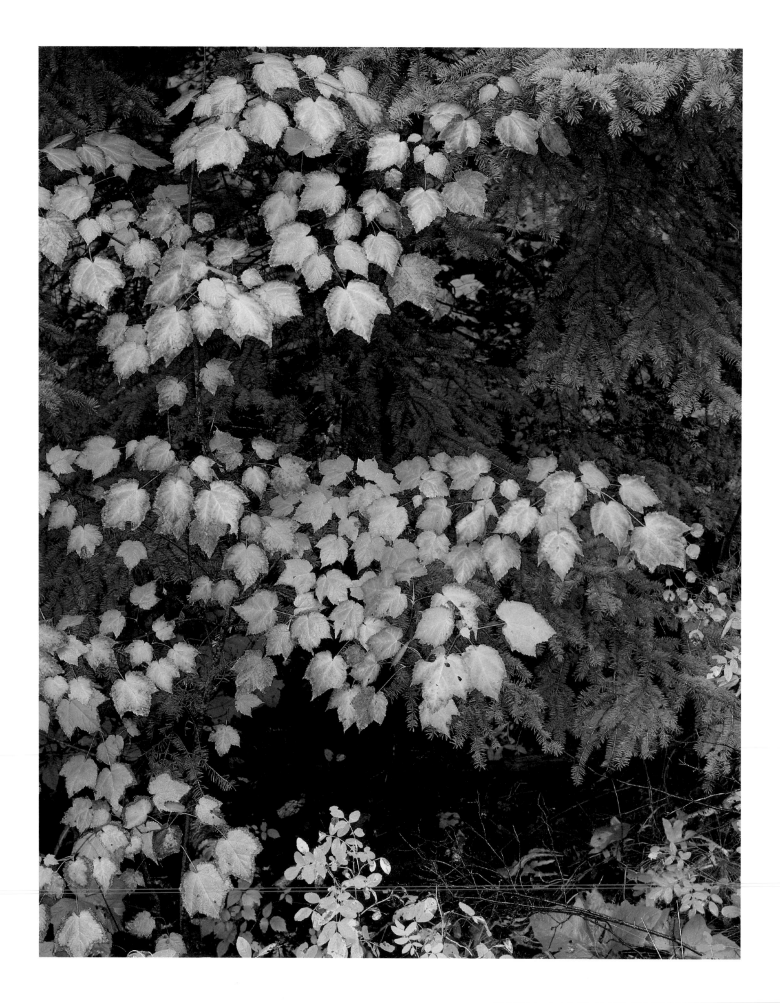

Red maple

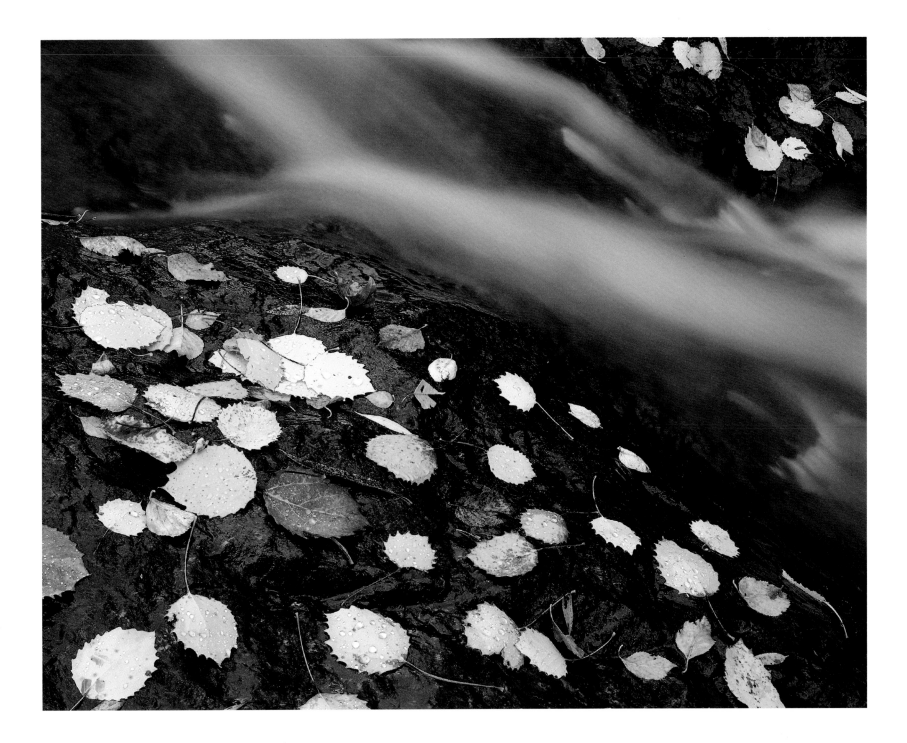

Bigtooth aspen leaves, Lincoln Park

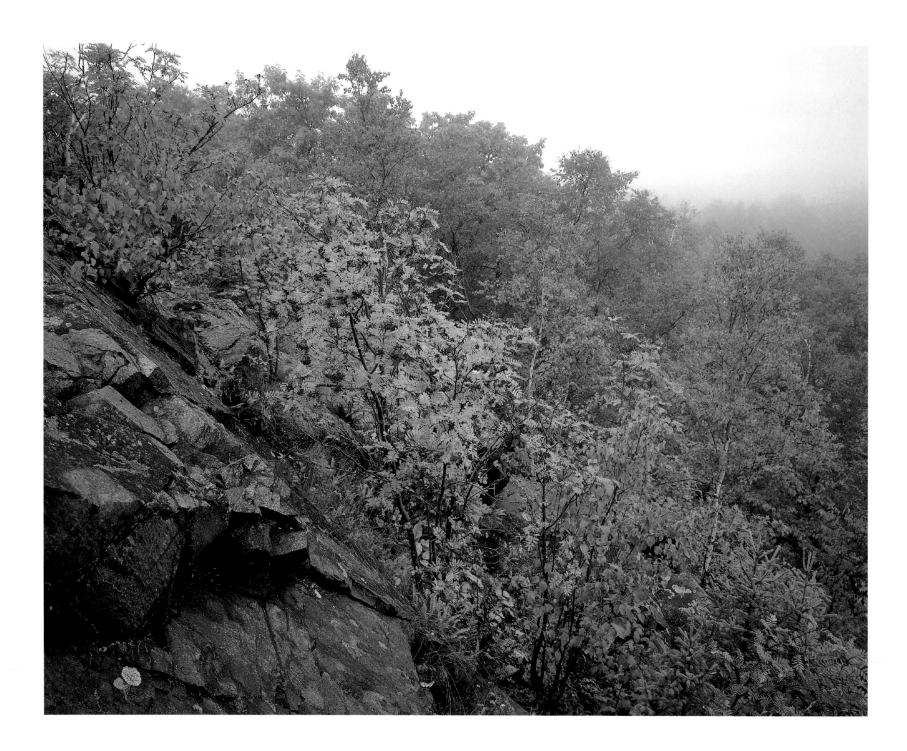

Mountain ash, Hartley Park

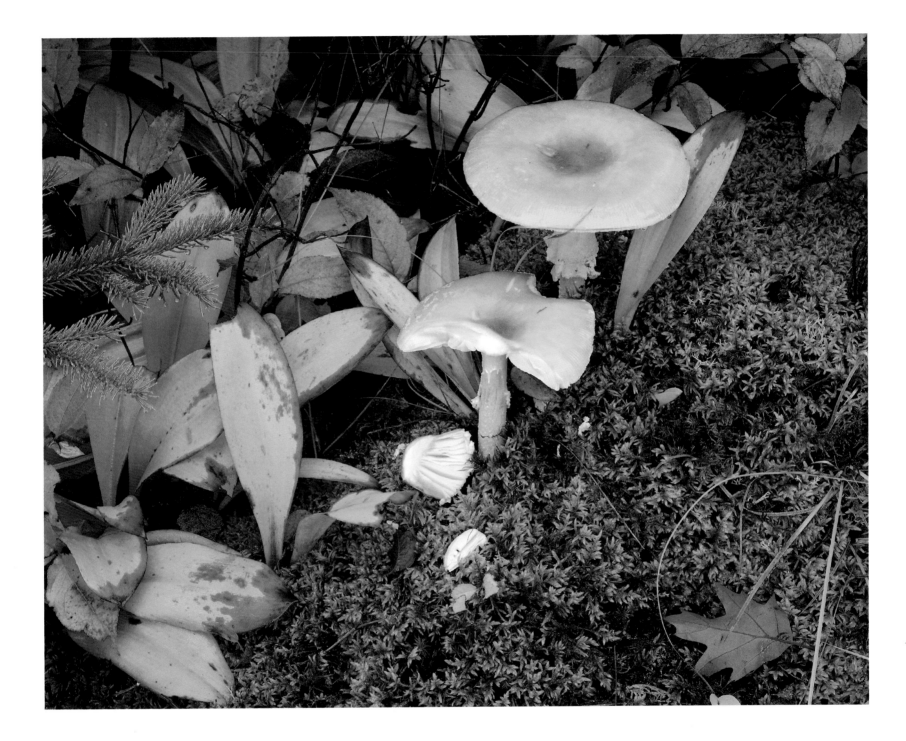

Yellow-orange fly agaric mushrooms

How freeing is a windy spring day! The air is crisp, but not raw; it whirls and blows the cobwebs out of our minds and long-swaddled bodies. It sets fresh bright aspen leaves shaking in their exhilarating dance.

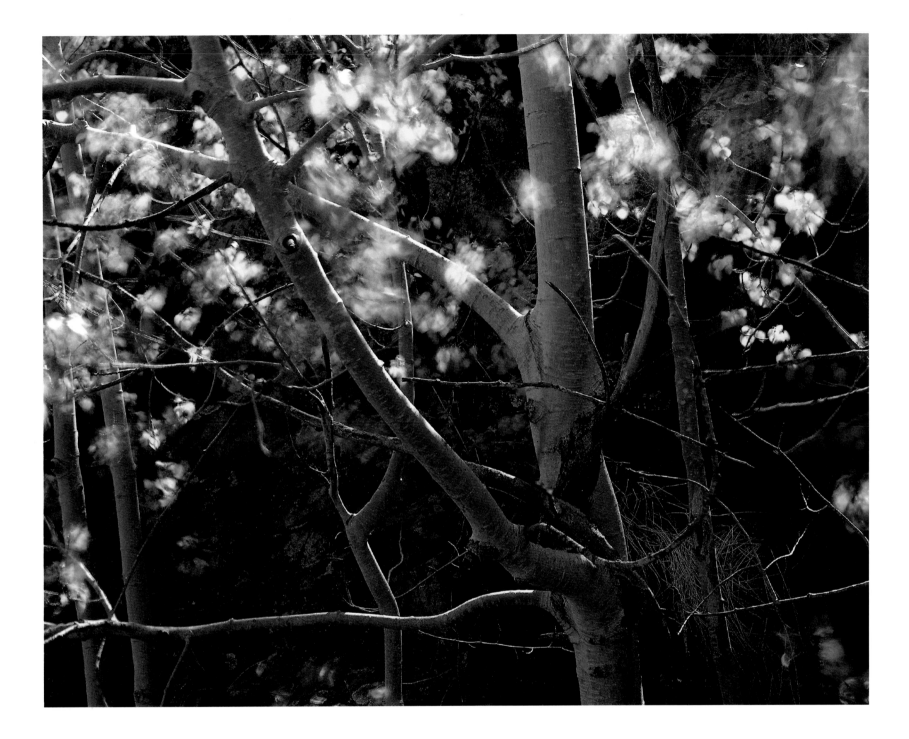

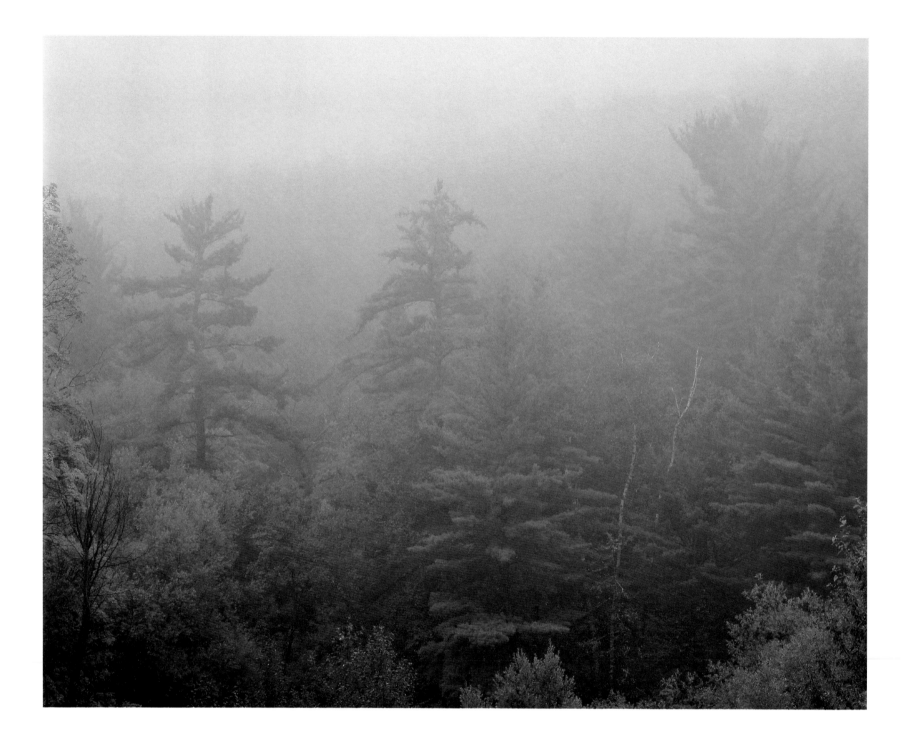

White pines, Chester Park

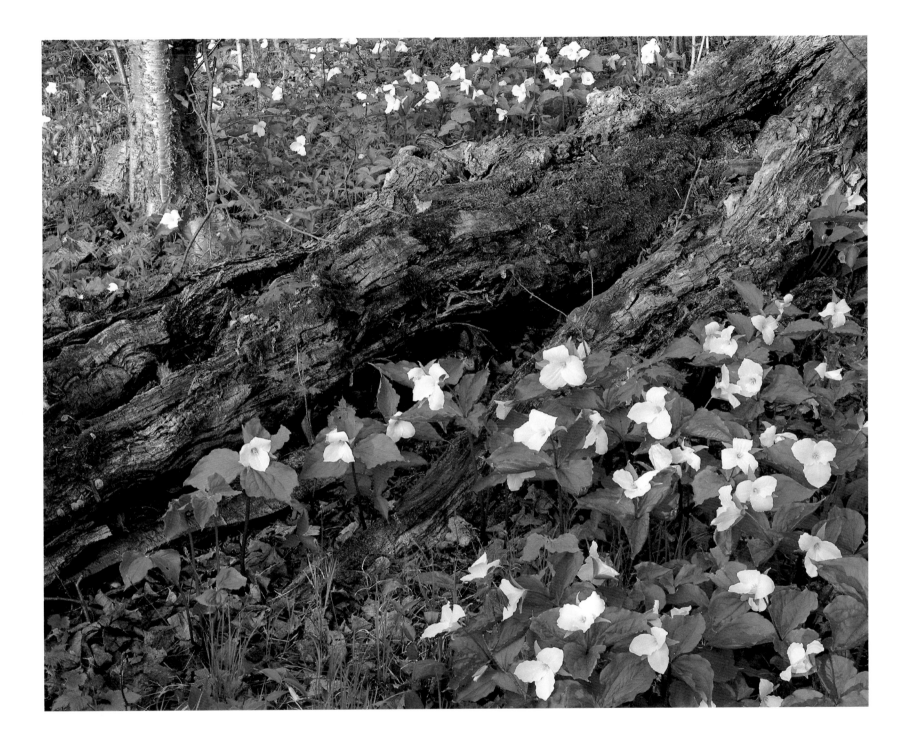

Large-flowered trilliums, Bardon Peak Park

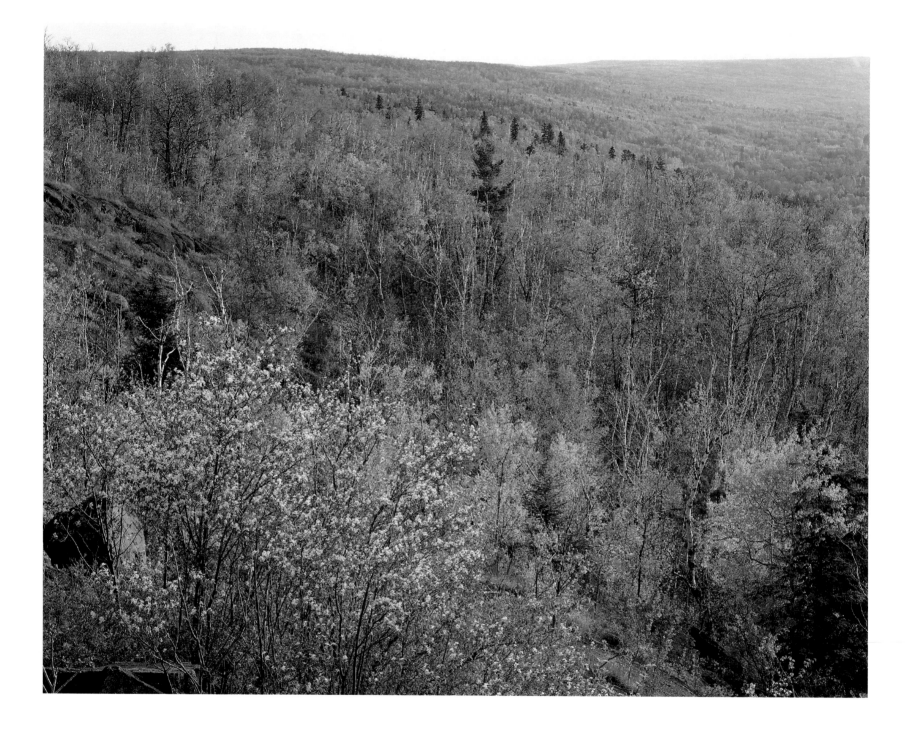

Juneberry flowers, Bardon Peak Park

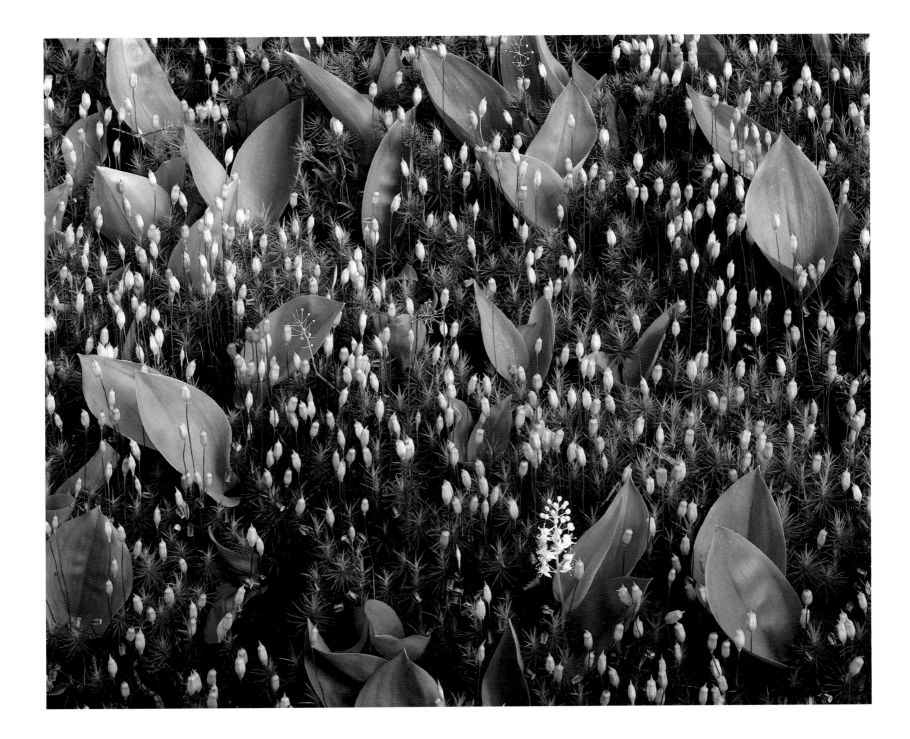

Haircap moss and Canada mayflower, Hartley Park

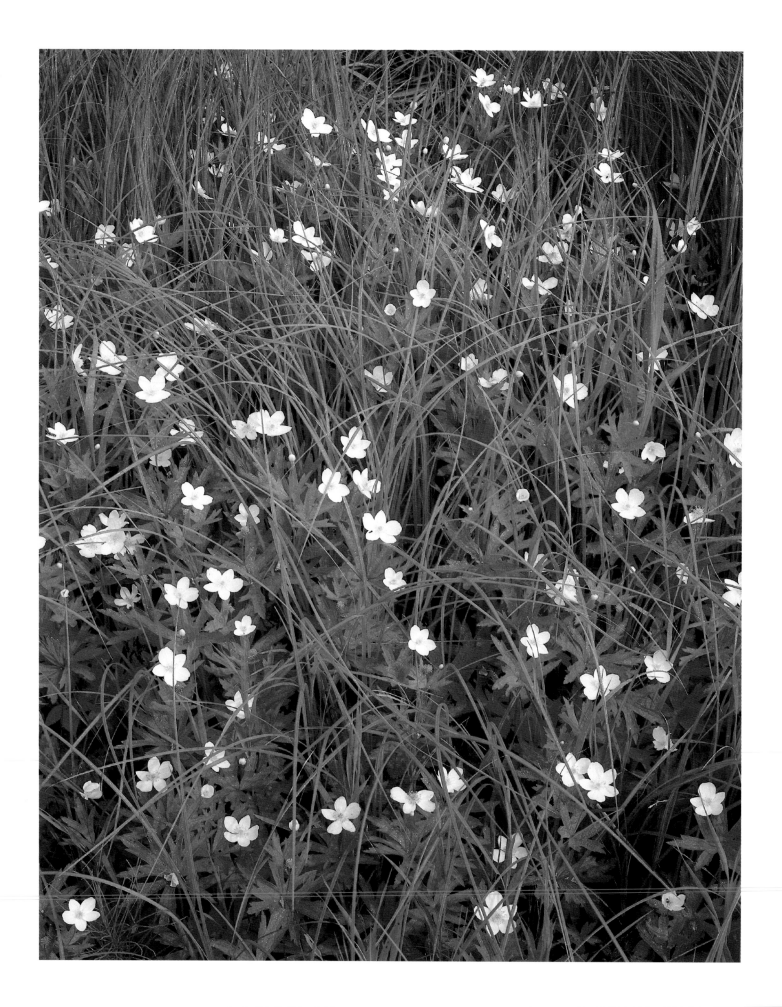

Canada anemone

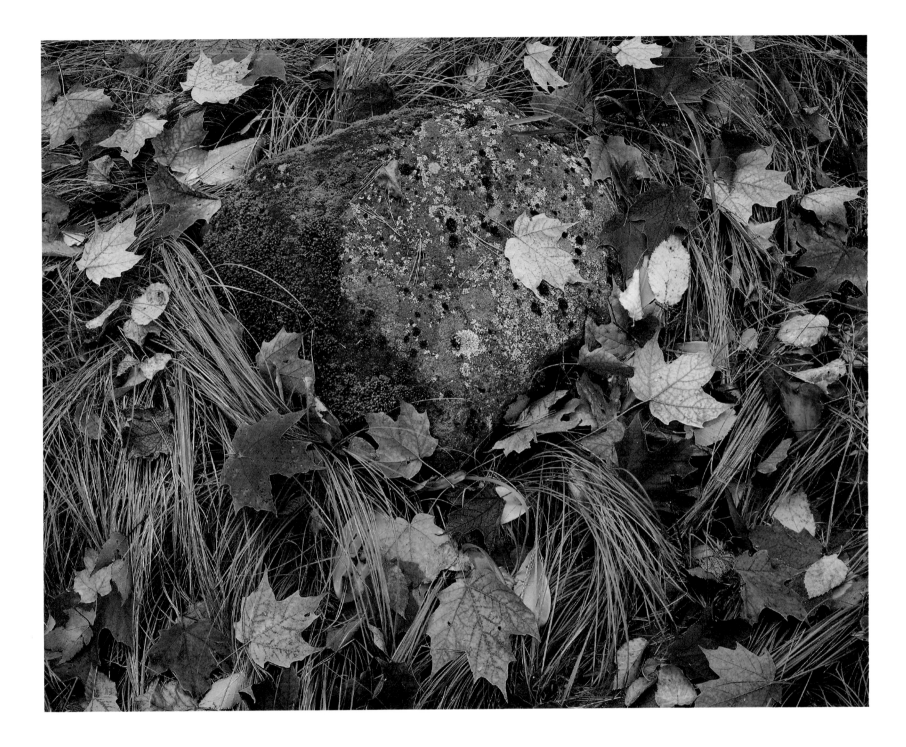

Sugar maple leaves, Bardon Peak Park

In the east end of Duluth, Skyline Parkway winds along a twelve-thousand-year-old beach terrace carved by Glacial Lake Duluth. Near Hawk Ridge, a favorite spot along the parkway to watch migrating raptors, you can look out over Lake Superior to the hills of the South Shore and barely notice the city below.

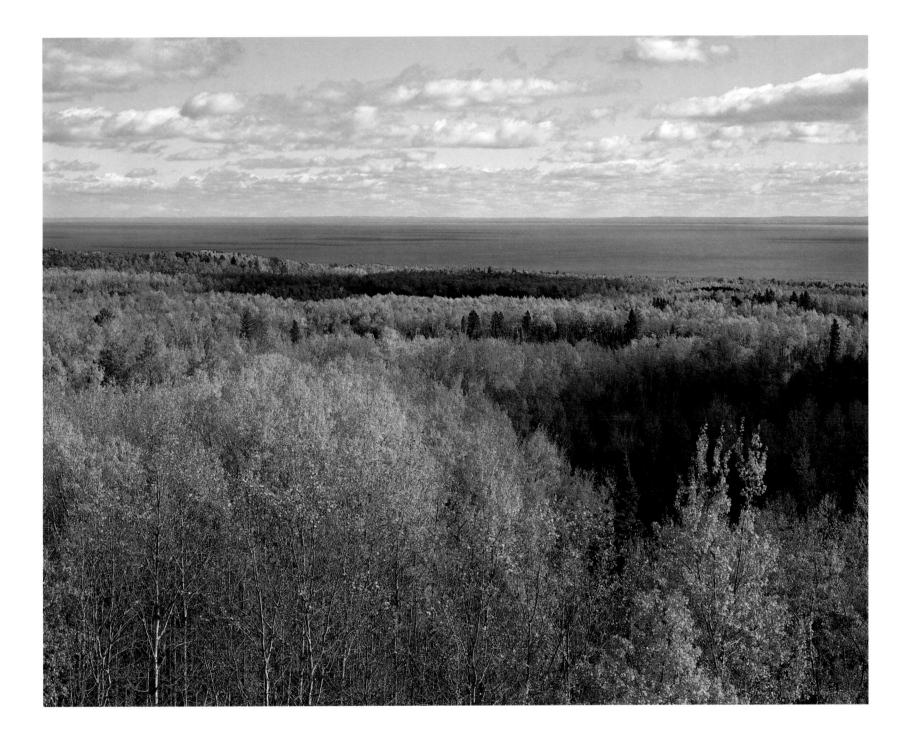

Long beech-fern

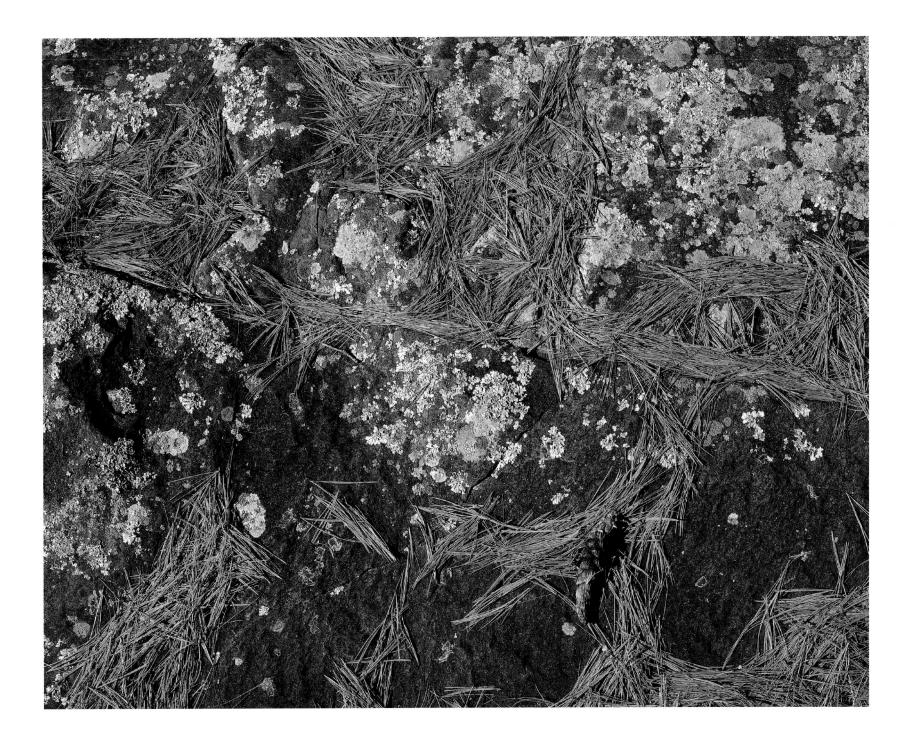

White pine needles

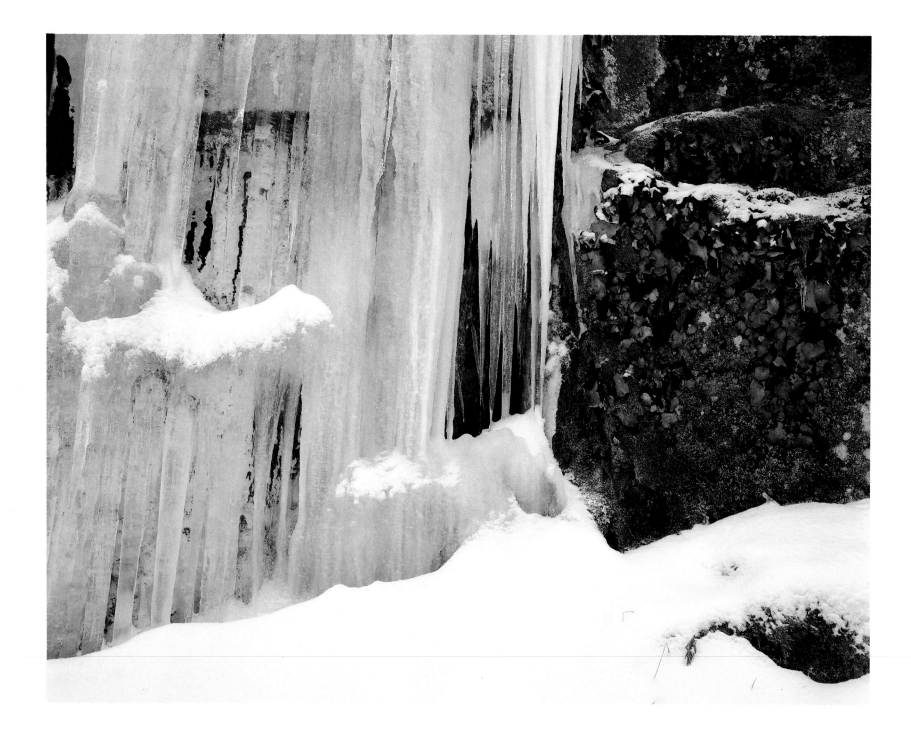

Icicles and lichens, Bardon Peak Park

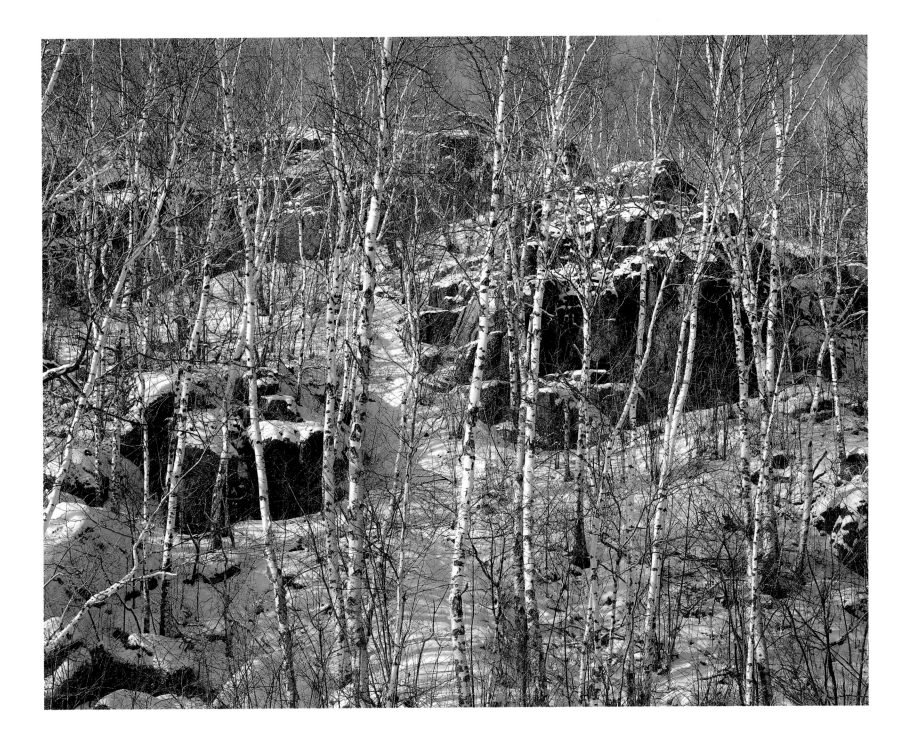

Paper birches and gabbro outcrops, Oneota Forest Park

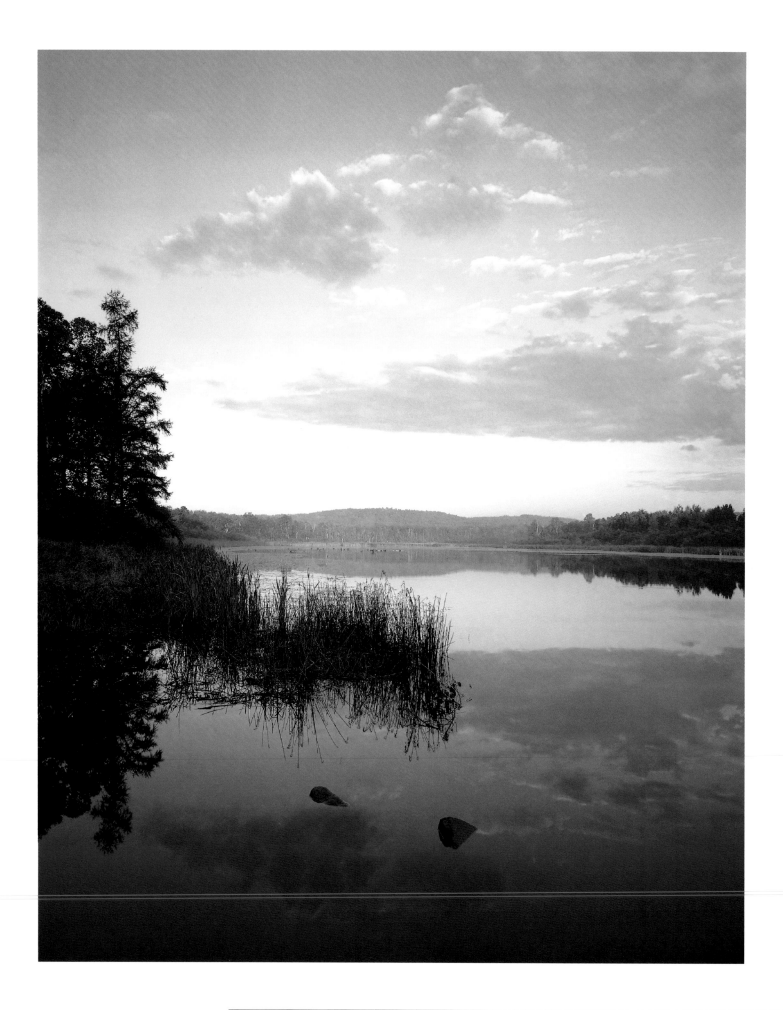

Hartley Pond, Hartley Park

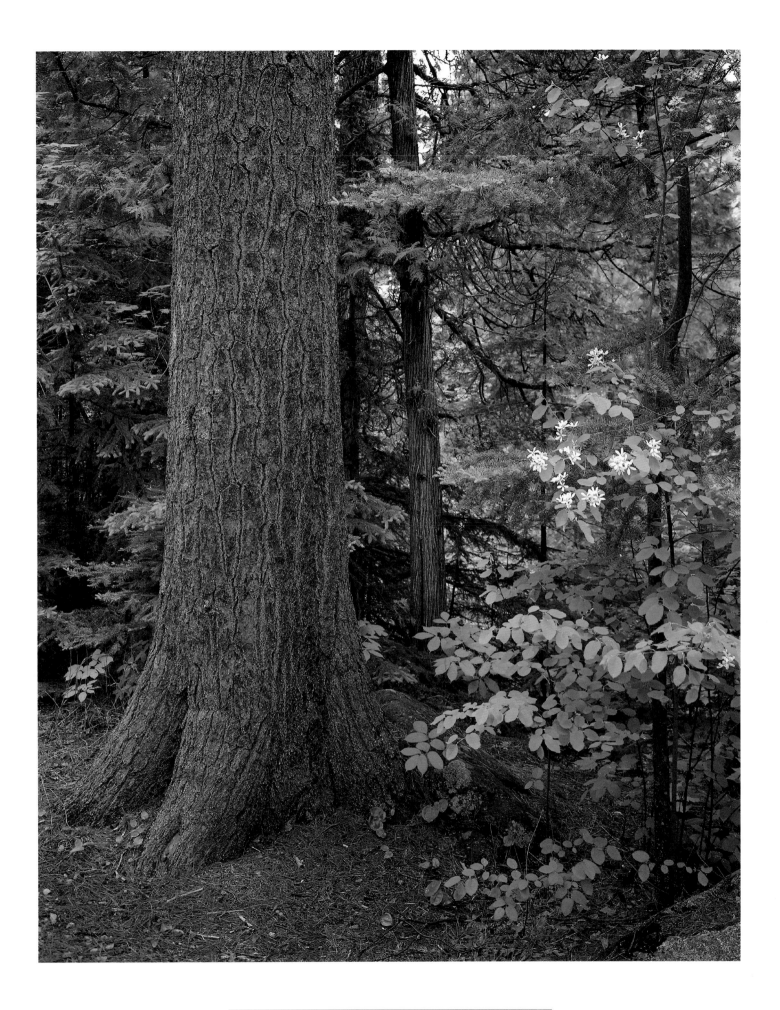

Juneberry flowers and white pine trunk, Lester Park

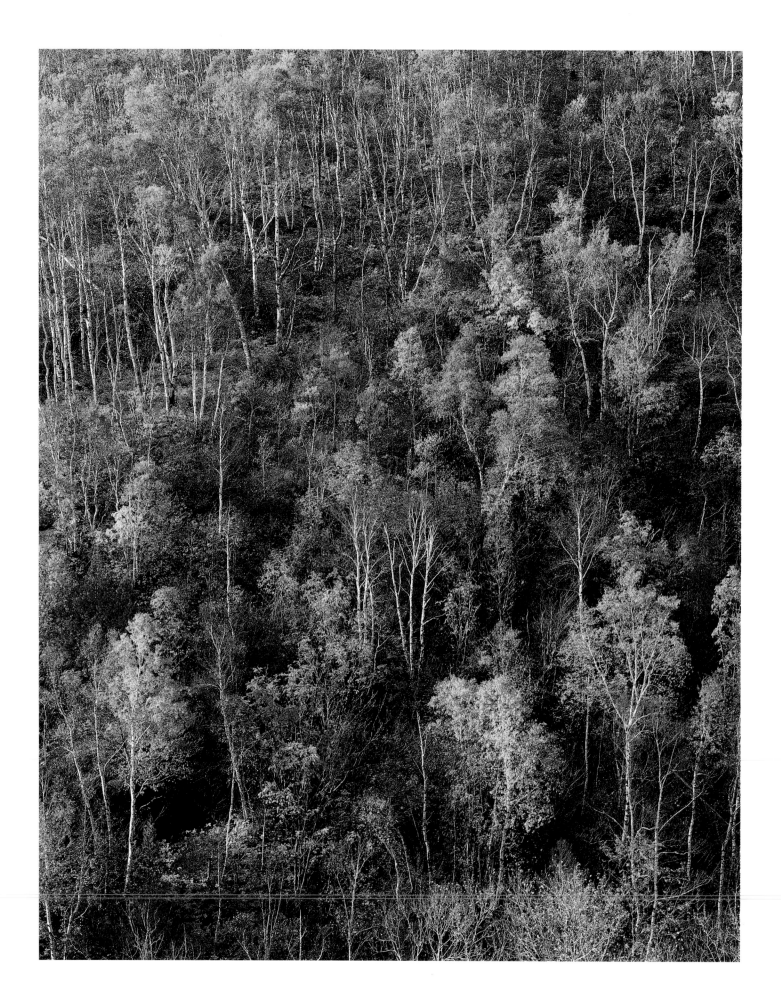

Paper birches, Oneota Forest Park

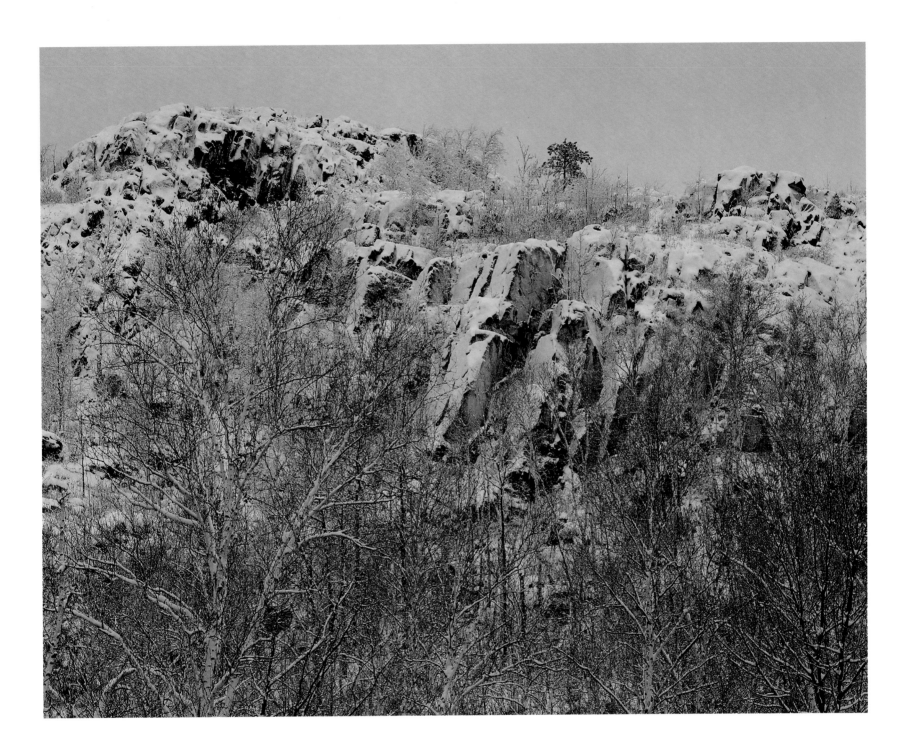

Basalt outcrops, Ely's Peak

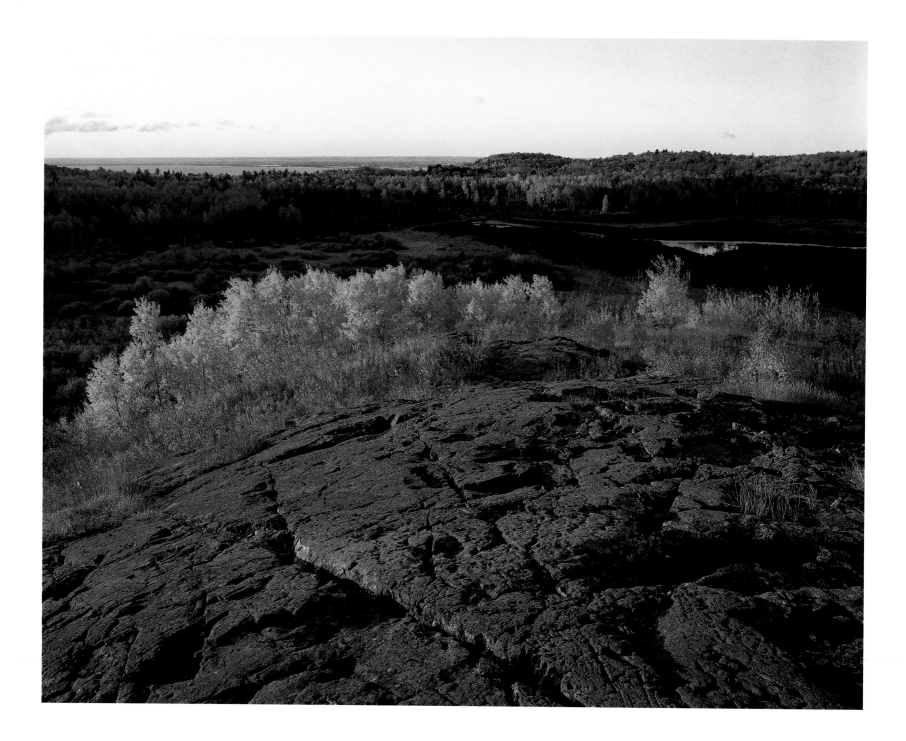

Basalt knob, Hartley Park

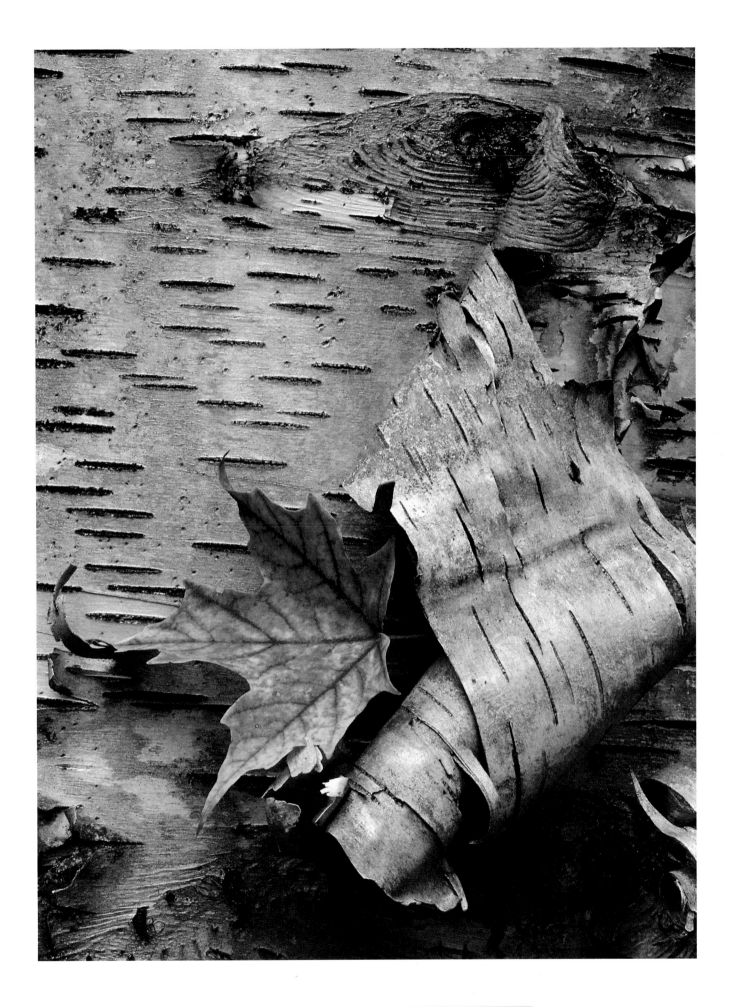

Sugar maple leaf on paper birch trunk

STREAMS & WATERFALLS

It is perhaps obvious that any city built on a hill formed of rock will have streams and waterfalls. Water follows gravity's pull, travels the path of least resistance, transitions into mesmerizing waterfalls when it spills over a ledge.

Duluth's rock is primarily basaltic lava flows and coarse-grained gabbroic rock. The lava flows can most easily be seen along the North Shore and at Lester River, Chester Creek, and Tischer Creek. Lester, near the eastern end of the city, is the only waterway, other than the St. Louis, large enough to be called a river. It runs wider with higher falls than the others and is a popular spot for fishing.

The smaller creeks weave in and out of residential areas; disappear underground through long culverts, reappear; meander and race. Towering pines shade the banks of Chester Creek and the lower reaches of Lester River. Cedars give a spicy northwoods air to rocky areas along several creeks. Bamboolike willow leaves form a canopy over stretches of many waterways. The willow trees' bright-red root threads at the water's edge are a striking, startling sight.

As I hike along Duluth's streams, it amazes me that I see few people. At Miller Creek, I come to a flat expanse of rock, perfect for reading or a picnic. Just a bit ahead a squat falls flows over large blocks of bedrock. I hear heavy traffic noise and see guard rails above me. Climbing to investigate, I find the junction of Highway 53, Skyline Parkway, and North 24th Avenue West. As often as I'd driven through that intersection, I had no idea what lay just out of sight.

Usually the white noise of flowing water masks sounds from nearby roads. In the deeper canyons, like those of Chester or Tischer Creeks, I am visually removed, as well, from the city. Walking along narrow paths strewn with pine needles and edged with bunchberries and rocky outcrops, I can almost believe I am hiking portages in the Boundary Waters Canoe Area. So it seems, too, along the upper reaches of Kingsbury Creek—quite a different feeling from being in the garden setting Kingsbury has in the Lake Superior Zoo grounds.

Even when streams can be seen from the road, they often retain a wild feeling. Deep woods line Seven Bridges Road as it passes back and forth over Amity Creek. The upstream view of Chester Creek from the 4th Street bridge is of tumbling waterfalls in a wooded setting—turn around and the scene changes incongruously to a bustling street with neighborhood shops. Stretches of Miller Creek are bordered by picnic tables and mown grass. Whether you seek a little wild or a lot of wild, some place along some creek in Duluth will fit your mood. —NB

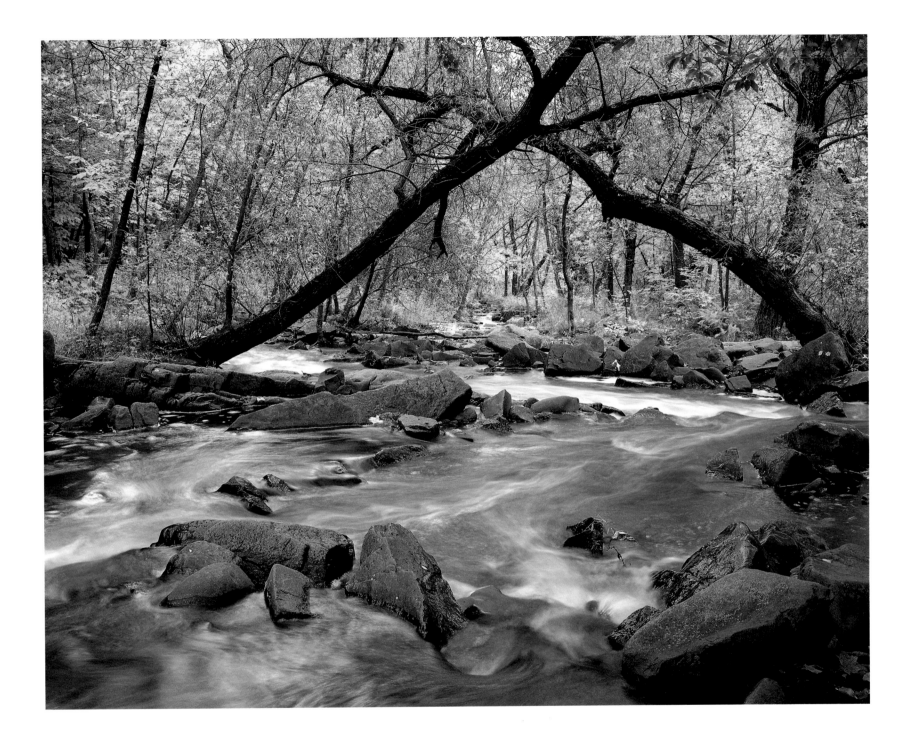

Miller Creek, Lincoln Park

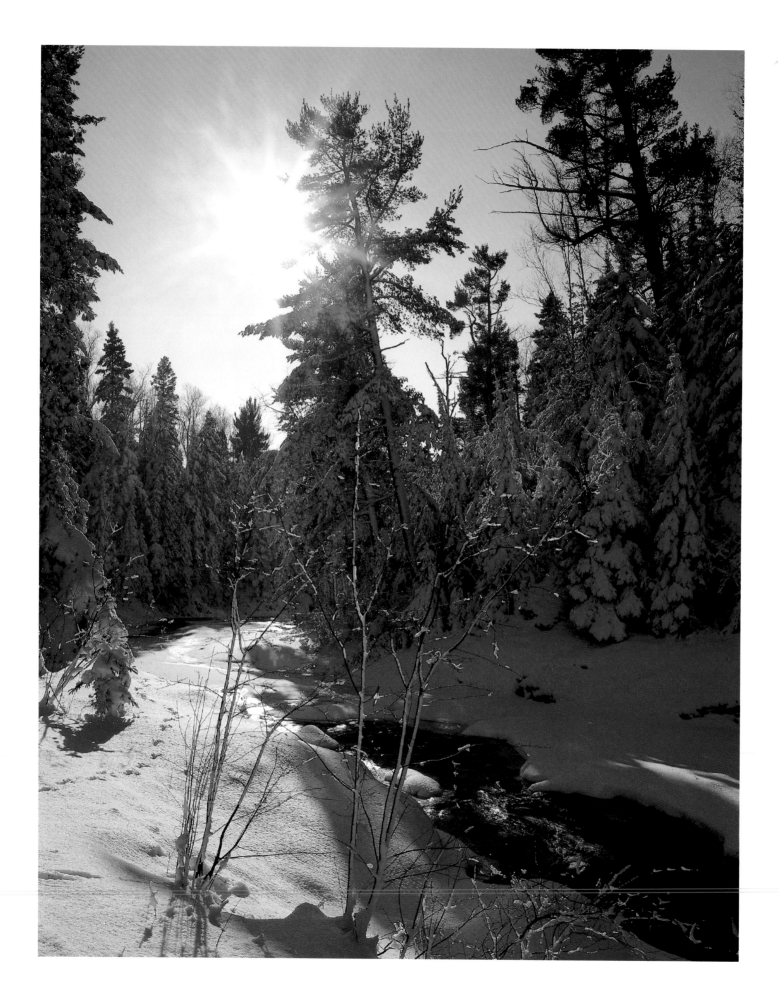

Lester River, Lester Park

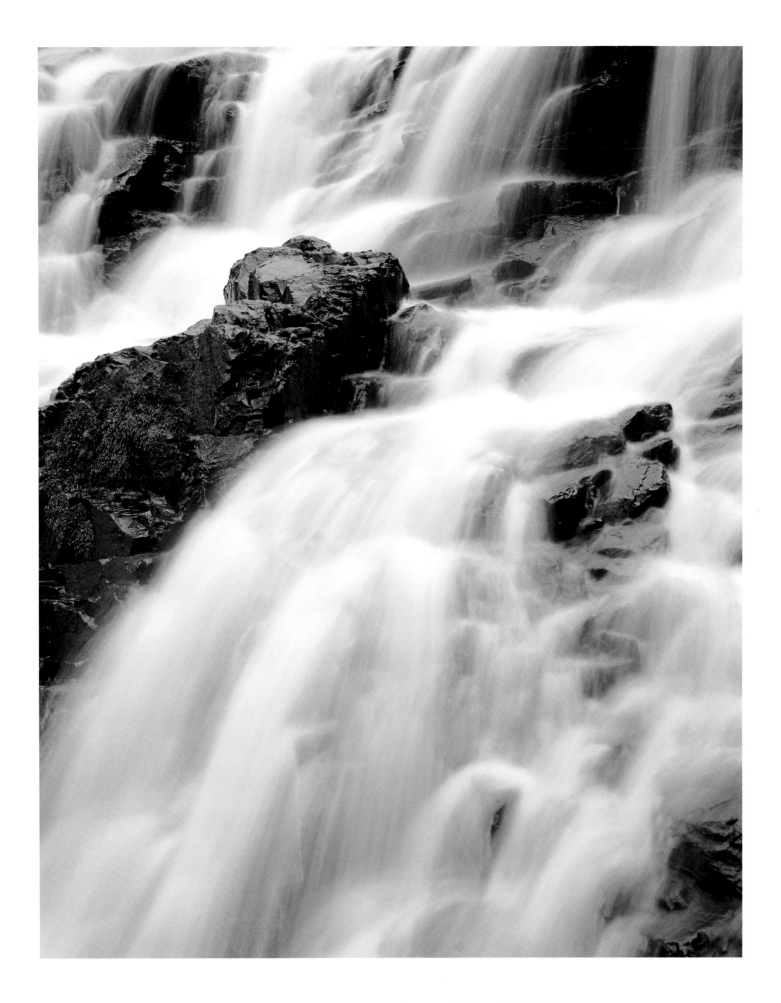

Chester Creek, Chester Park

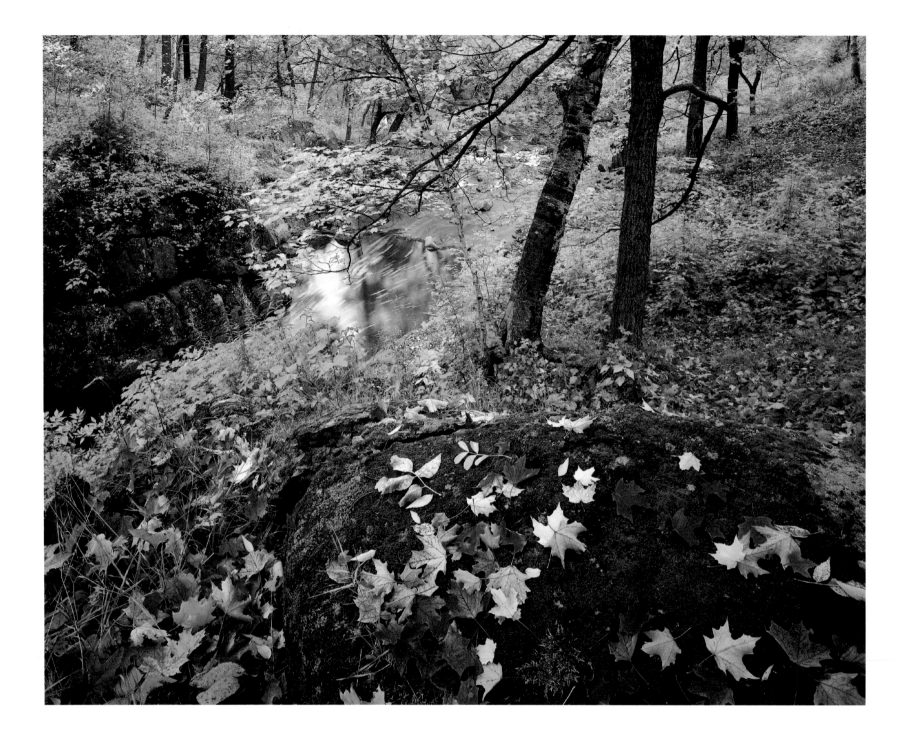

Sugar maple leaves, Miller Creek, Lincoln Park

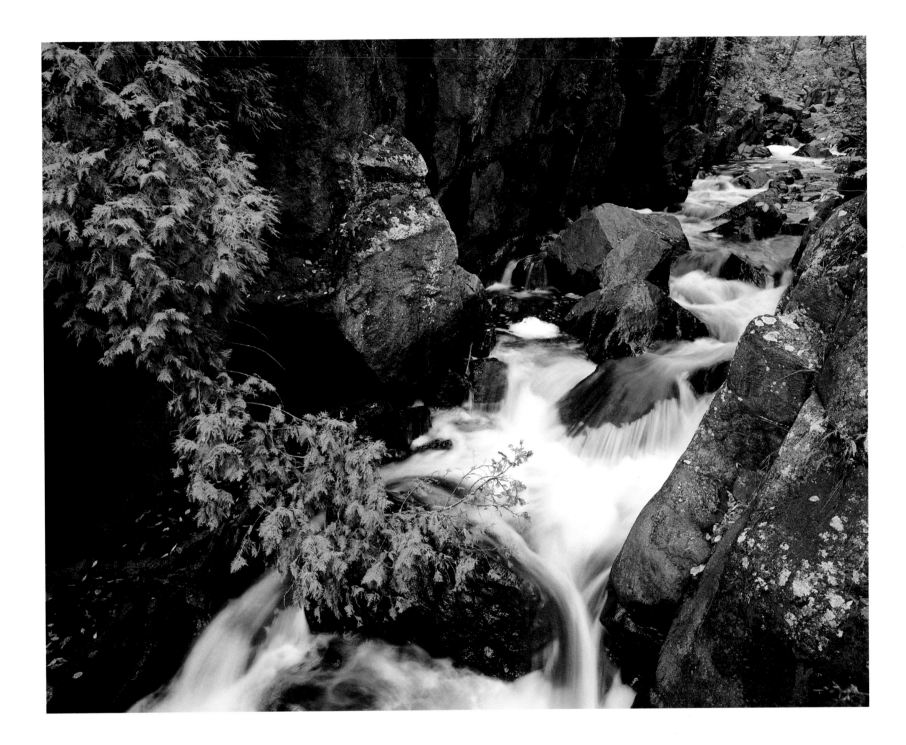

White cedar, Miller Creek, Lincoln Park

We stop to admire this rock and water combination nearly every time we drive by it on Skyline Parkway.
This time a single marsh marigold blossom prompts us to make the photograph.

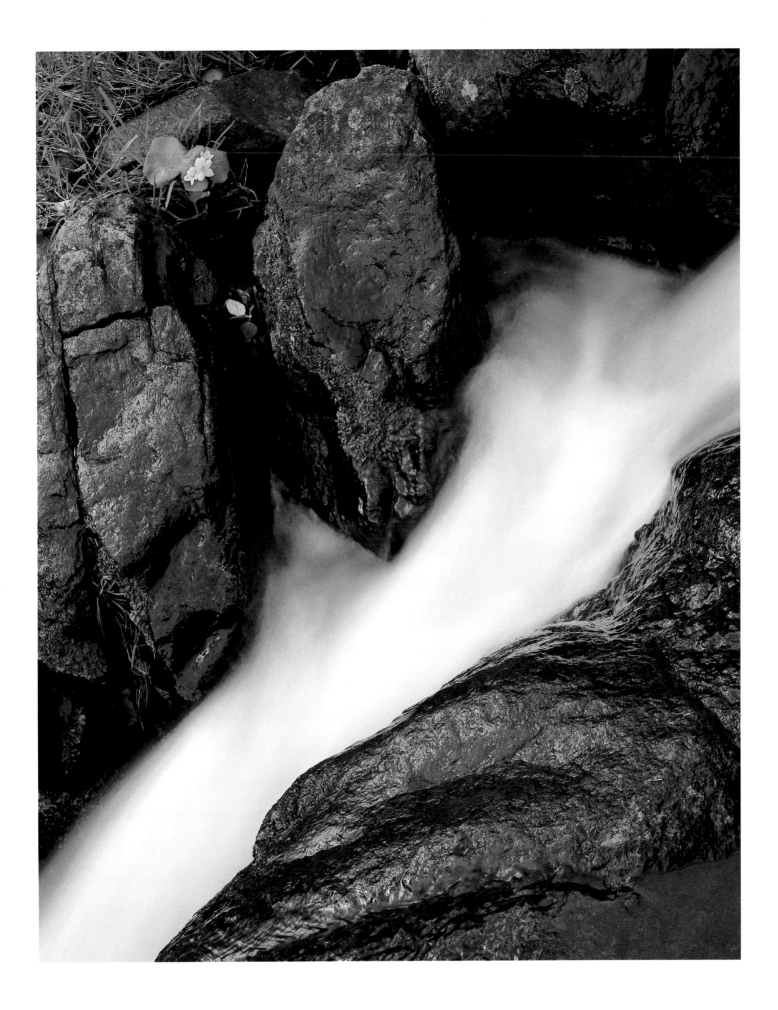

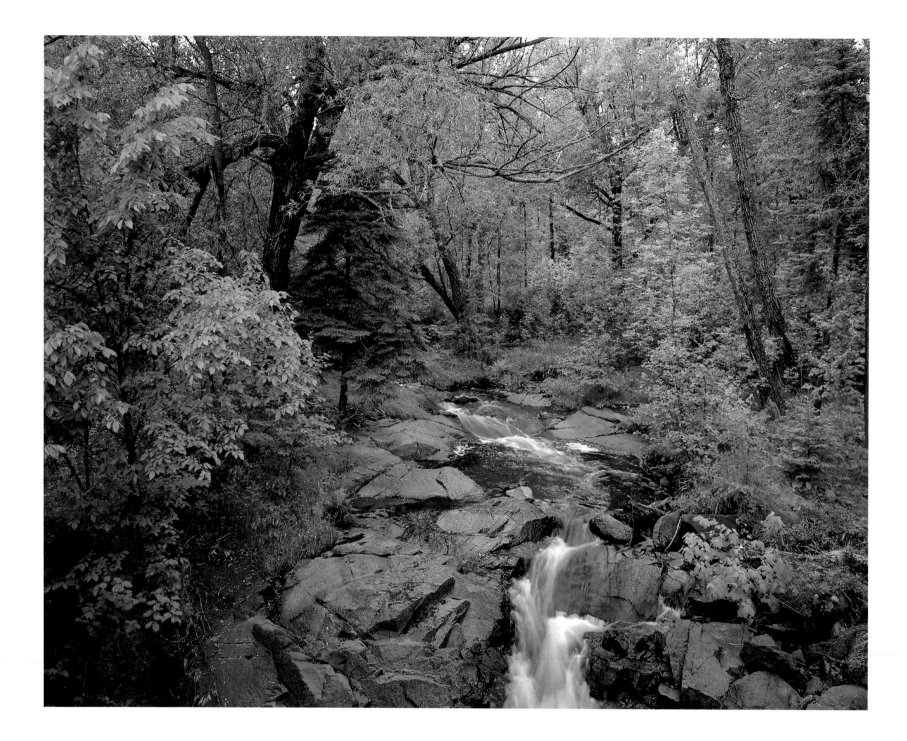

Tischer Creek, Congdon Park

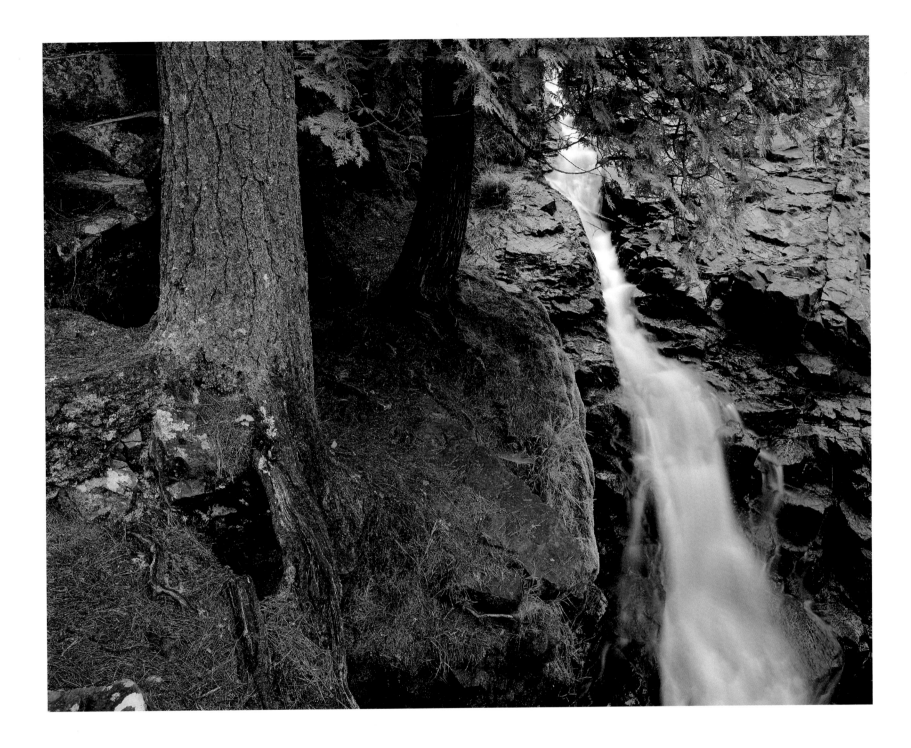

Chester Creek, Chester Park

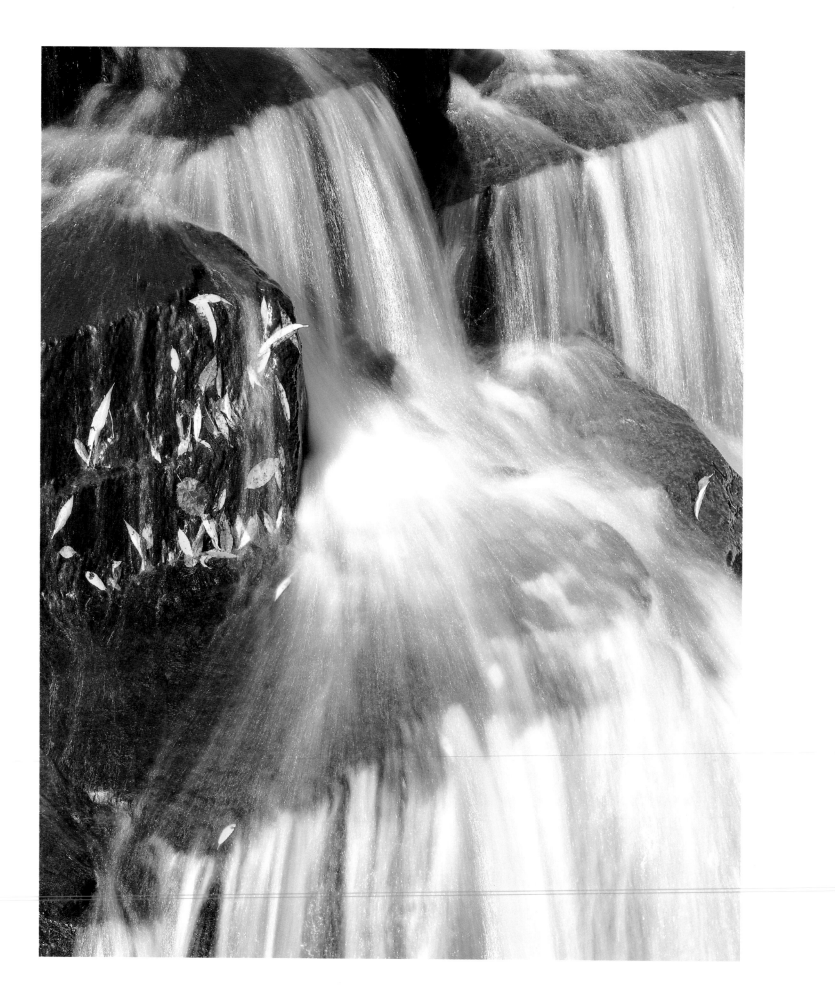

Willow leaves, Miller Creek, Lincoln Park

Leaves and white pine needles, Lincoln Park

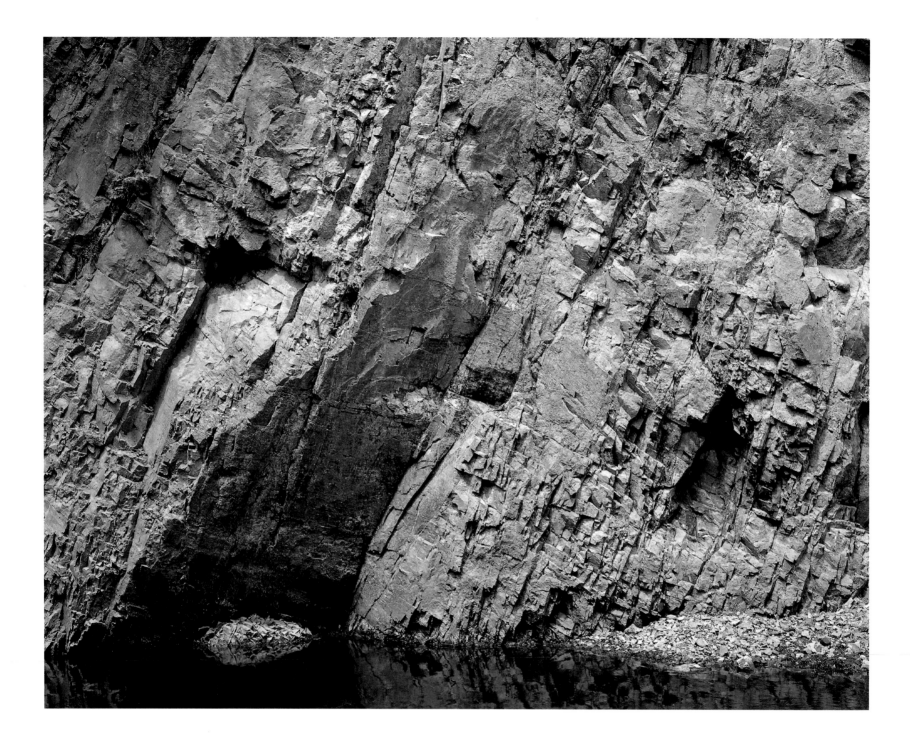

Rhyolite canyon wall of Tischer Creek

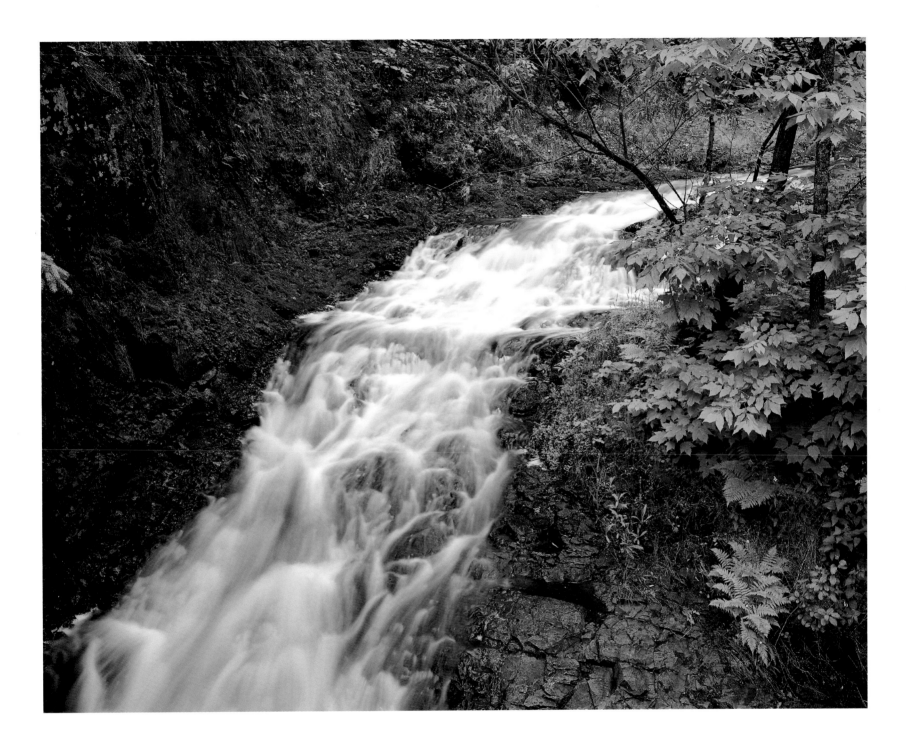

Tischer Creek, Congdon Park

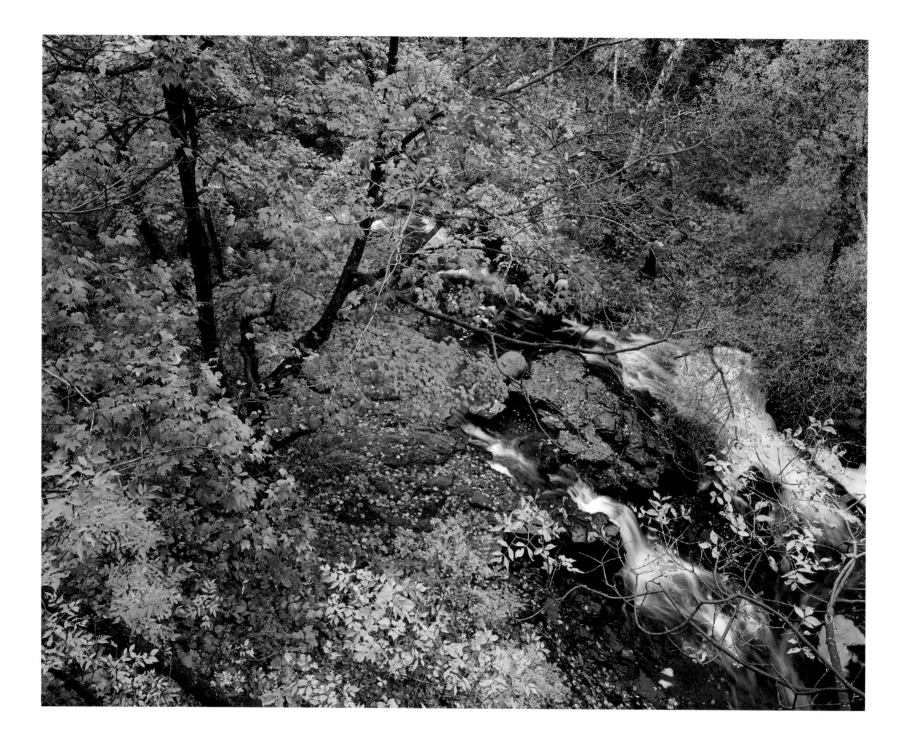

Miller Creek, Lincoln Park

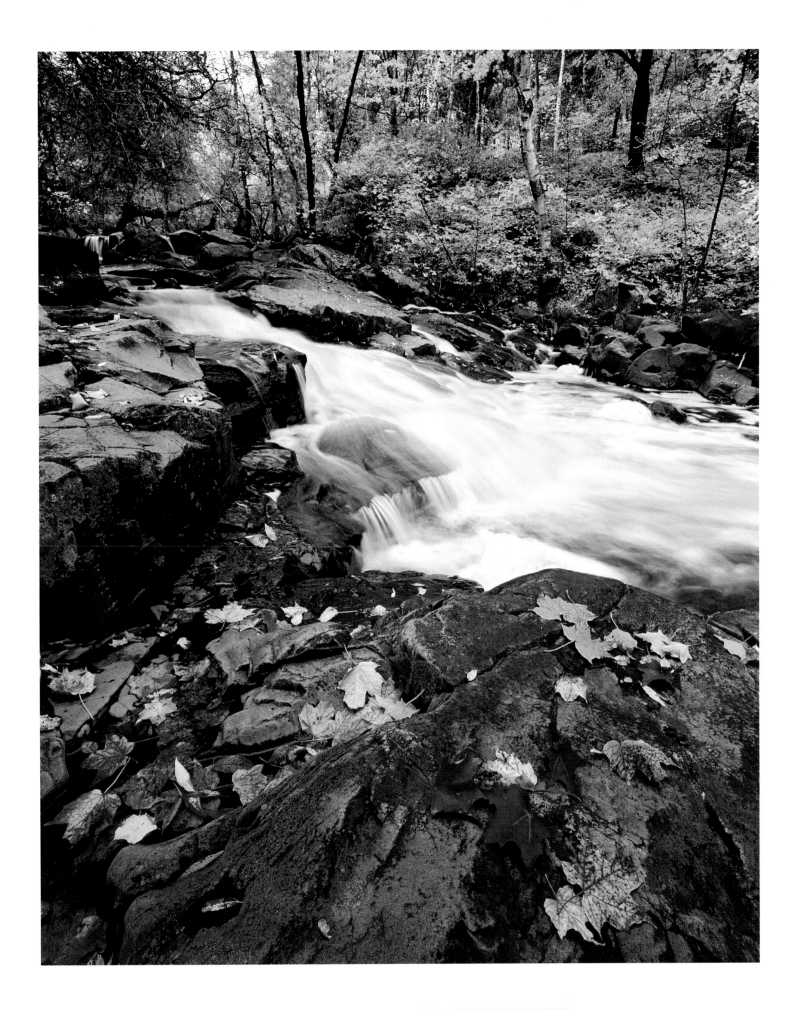

Miller Creek, Lincoln Park

Near Seven Bridges Road, Amity Creek tumbles over boulders and down sluiceways. Interspersed are irresistable, smooth-rock pools just right for summer cool-downs.

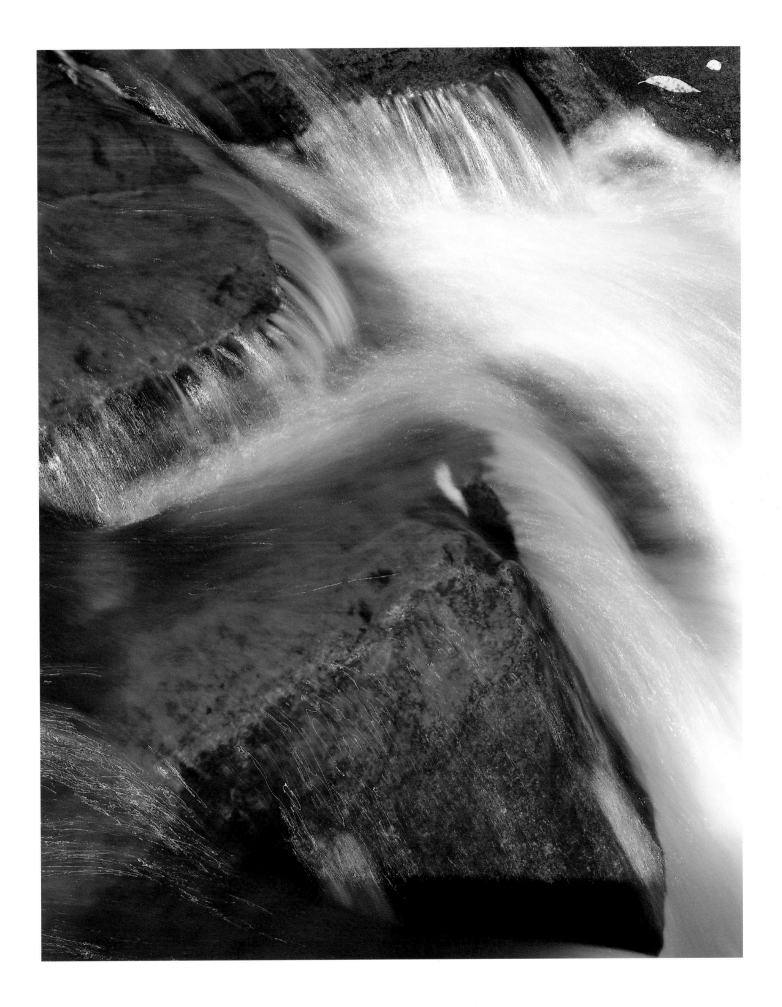

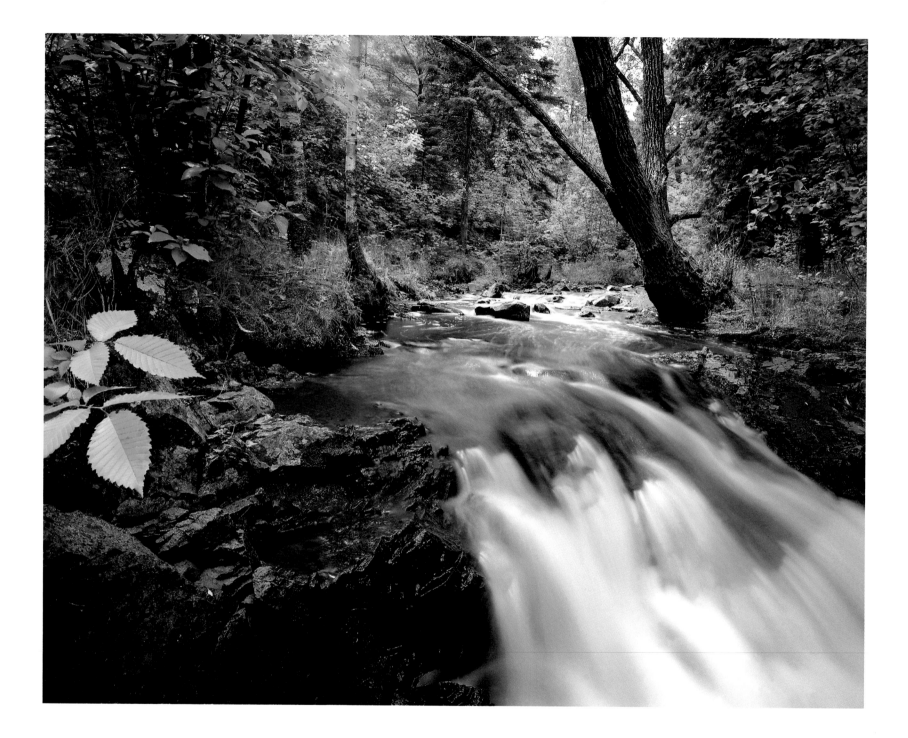

Tischer Creek, Congdon Park

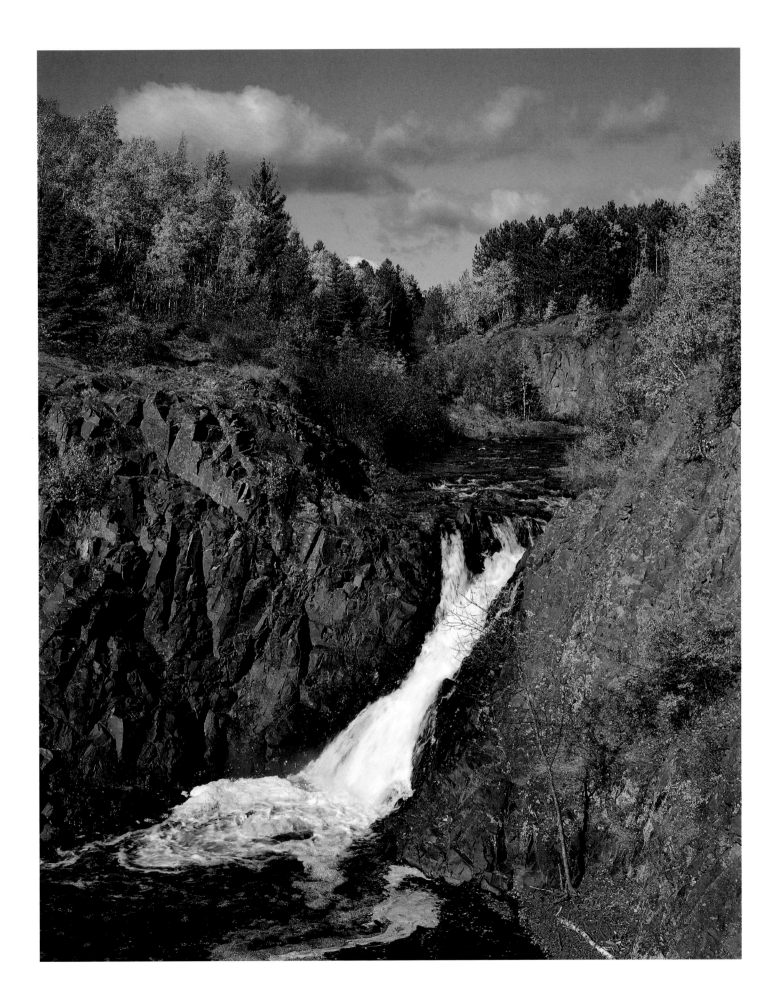

Lester River, Lester Park

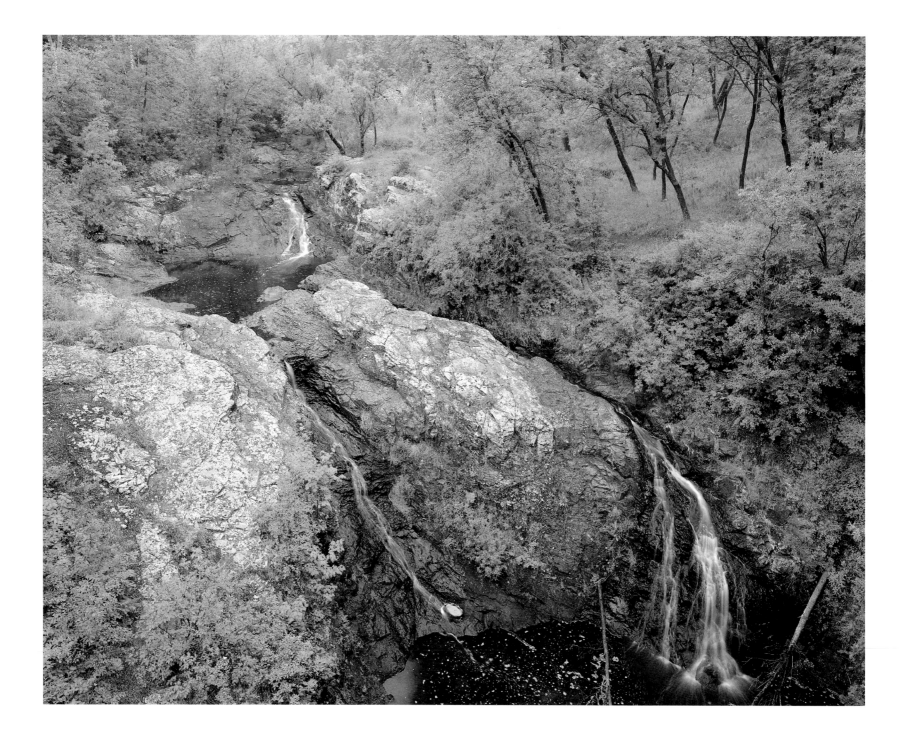

Chester Creek, Chester Park

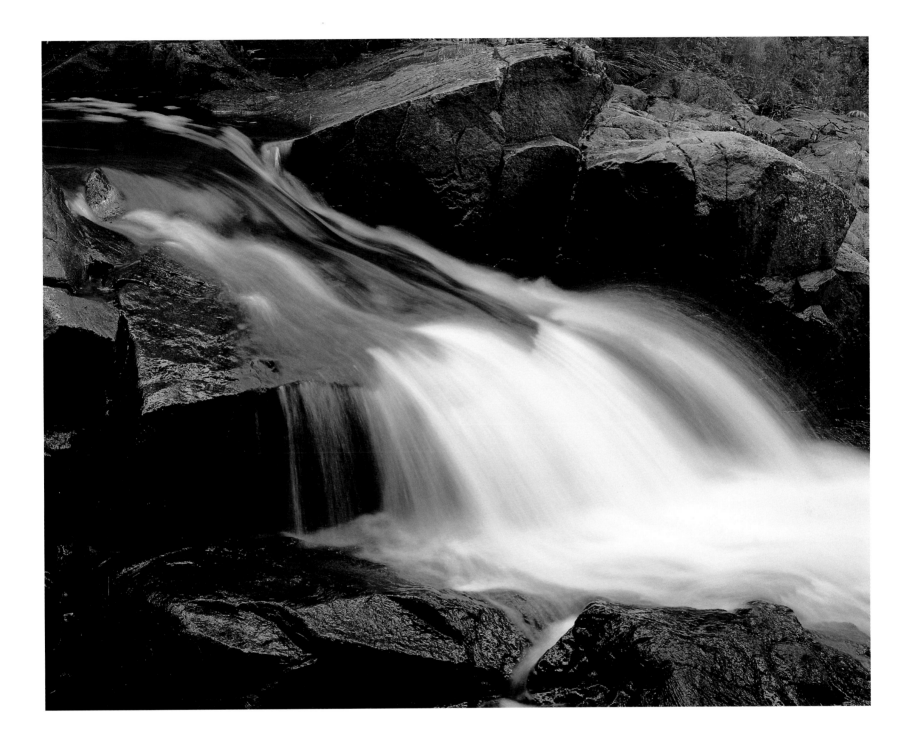

Tischer Creek, Congdon Park

NORTH SHORE

For the fifth time this summer I take my camera down to a stretch of shoreline that has several possibilities for close-up photographs. One composition in particular has haunted me: a crescent-shaped puddle cupped in smooth, gray bedrock. The rock wraps partway around a bed of pink pebbles and a boulder. In calm weather, the boulder and pebbles are dry. When the winds are gusty, swells cover the entire area. If I time my visit to coincide with small waves, the conditions are perfect: Water swirls around the boulder, wetting some of the pebbles, turning them ruddy brown.

After many years of photographing Lake Superior, it is most often these small shoreline features that beckon us to photograph them. A fragment of ice can become a universe of bubbles; a vein of calcite, a distant horizon or bolt of lightning. Each invites our imaginations to change the abstract into the known. There is something magical about this illusion of a larger reality—just as the confined space of a Japanese garden leads the mind across seas to faraway islands.

Although the basalt I am walking on flowed from the ground as lava over a billion years ago, it has been only 10,000 years since the glaciers finally melted from our region. Glacial Lake Duluth, Lake Superior's ancestor, once flooded most of present-day Duluth, reaching the level of Skyline Parkway. Lake Superior attained its present level only four thousand years ago. This is an ancient, but freshly scrubbed, piece of the earth. I close my eyes and run my fingertips over the rock, feeling parallel scratches, making a physical connection to the rock-laden ice that etched them.

On bitterly cold winter days when lake fog billows up and sheets of ice slide along the shore, it seems the astringent cleansing of the ice ages is still at work. Each spring, as the ice and snow recede, we marvel at the resurrection of life on the shore. How could anything have survived the cold and the pummeling of ice shards? Yet, here the frailest of flowers burst forth from seemingly bare rock. Farther towards the woods, tufts of sedges surround each pool of water. A little farther still nine-bark grows in mounds—its white flowers turning rusty as the season progresses.

Whether sparkling azure or dull slate-gray, Superior's waters are an ever-present backdrop to the Duluth landscape. The lake has provided the economic basis for the city's existence from fur-trading days through present-day grain and iron ore shipping. Ironically, Duluth, the most populous city on Lake Superior, possesses some of Minnesota's largest stretches of publicly owned shoreline. While some county commissioners further north would sacrifice the public's access to the lakeshore in favor of residential and commercial development, Duluth is making the most of its public lakeshore, enriching the lives of its citizens and attracting thousands of visitors yearly from around the world. —CB

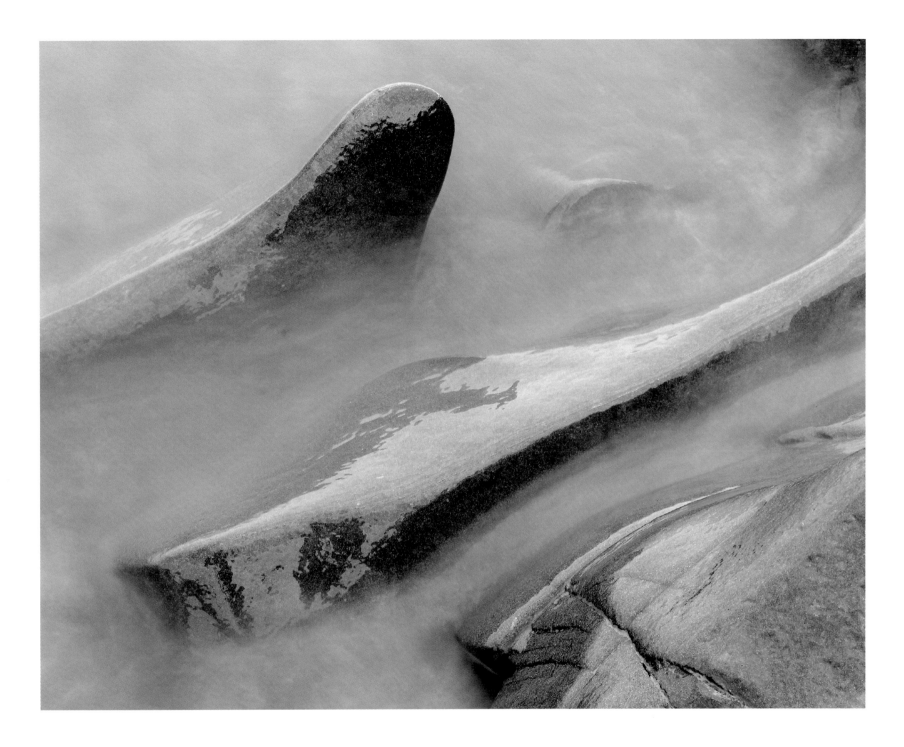

Lake Superior, Kitchi Gammi Park (Brighton Beach)

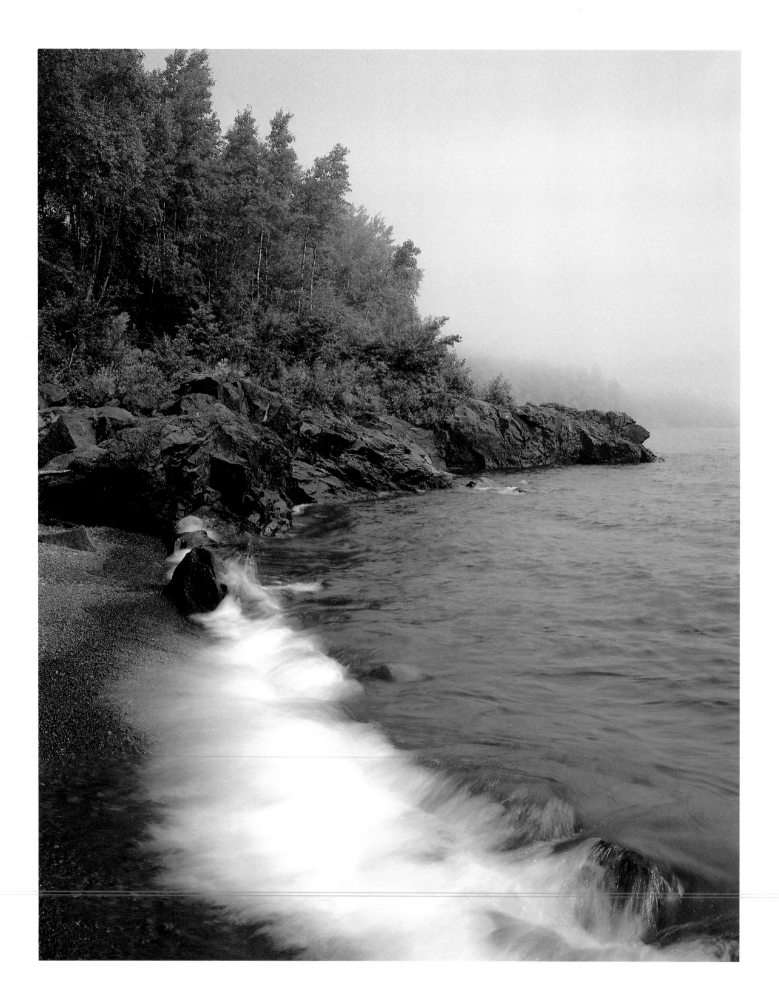

Lake Superior, Kitchi Gammi Park

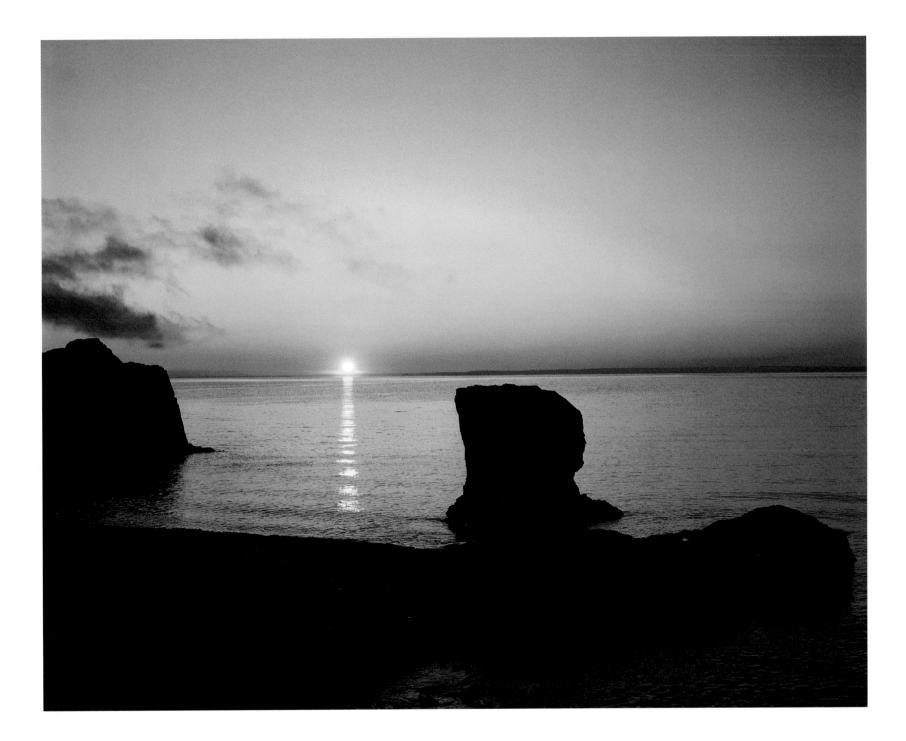

Sunrise, Lake Superior, Leif Ericson Park

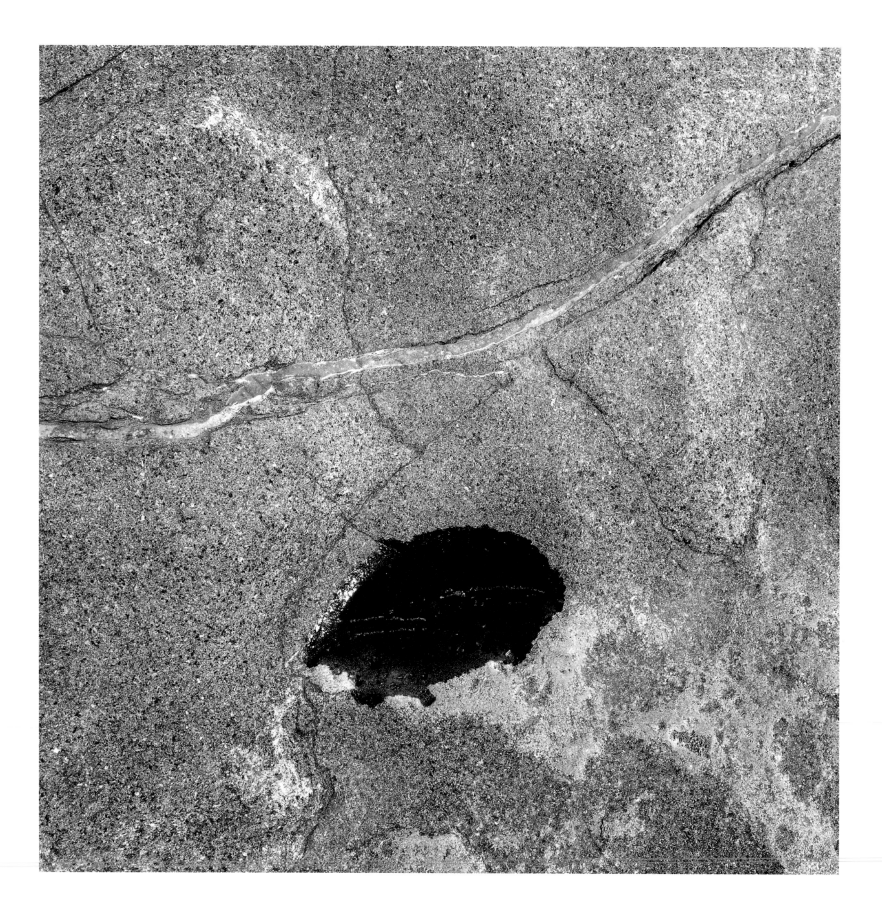

Puddle with red algae, Kitchi Gammi Park

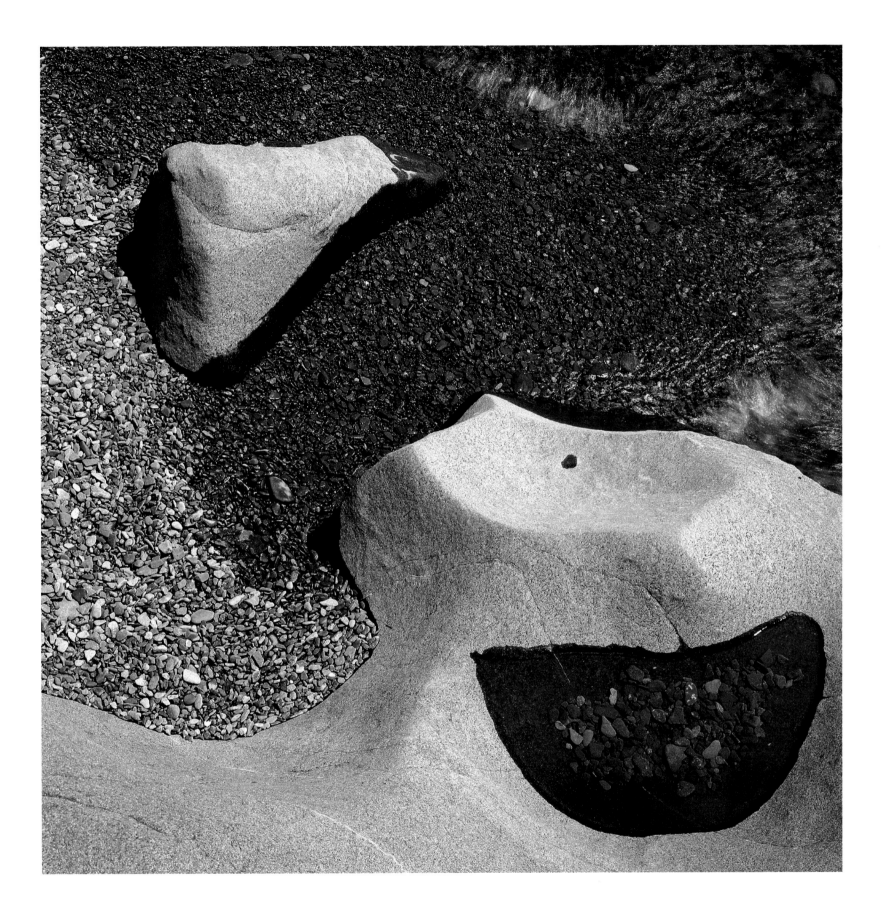

Rock, pebbles, Lake Superior

If the lake is gently rocking, I am calmed by the rhythm. If the wind pushes like a Sumo wrestler I lean against it, answering the challenge. Other days I shuffle slowly through pebbles, setting them clattering like marbles rolling under my feet.

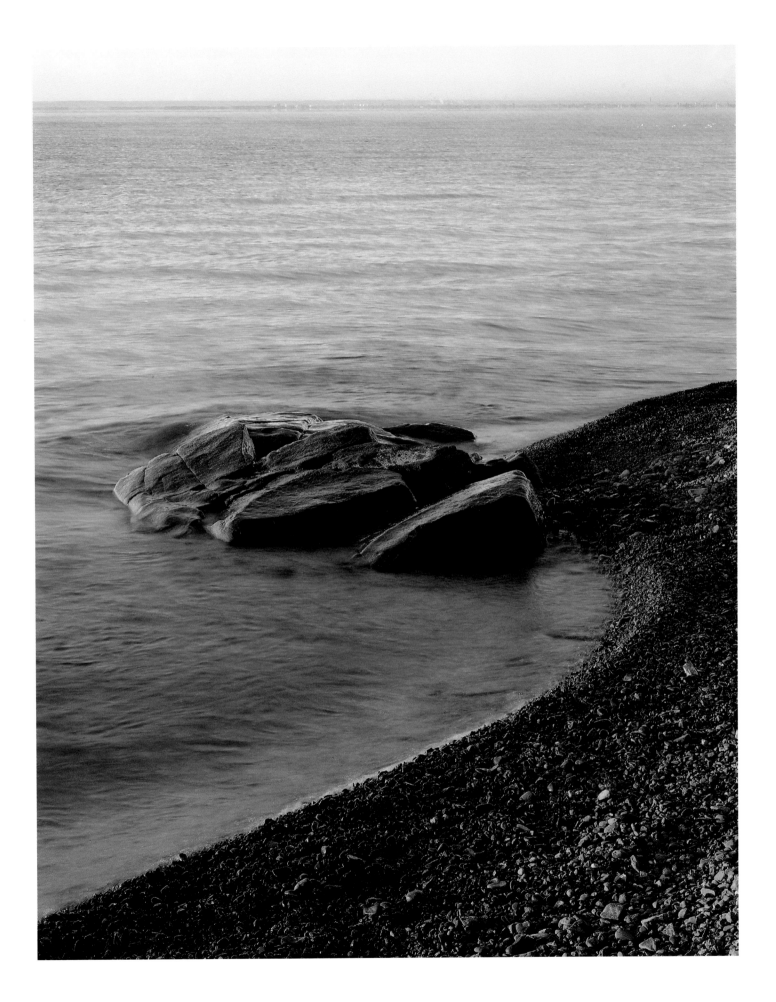

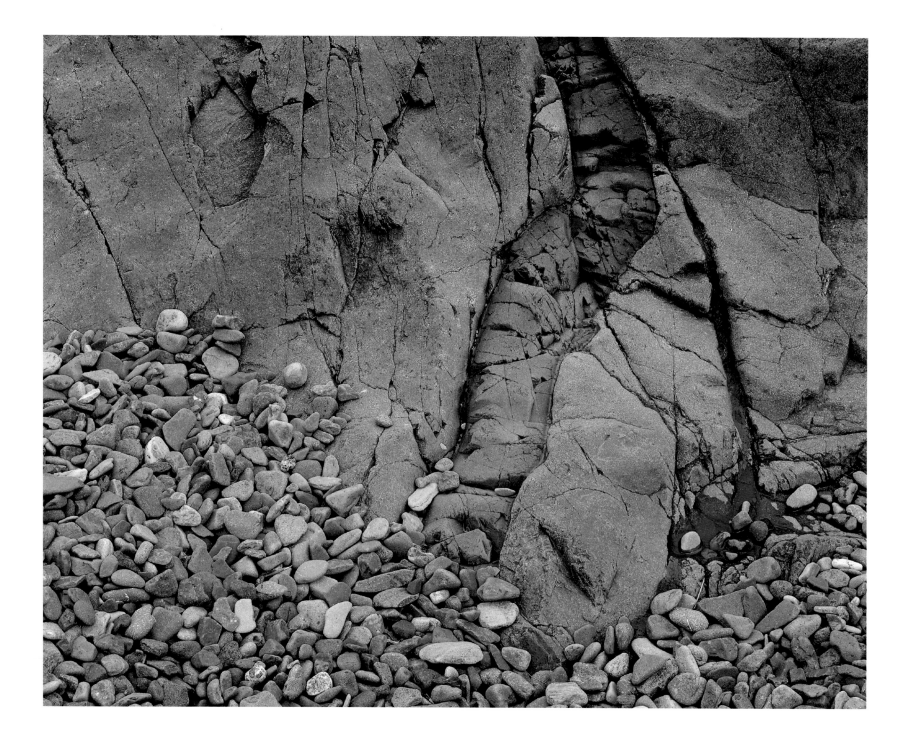

Basalt dike below Downtown Lakewalk

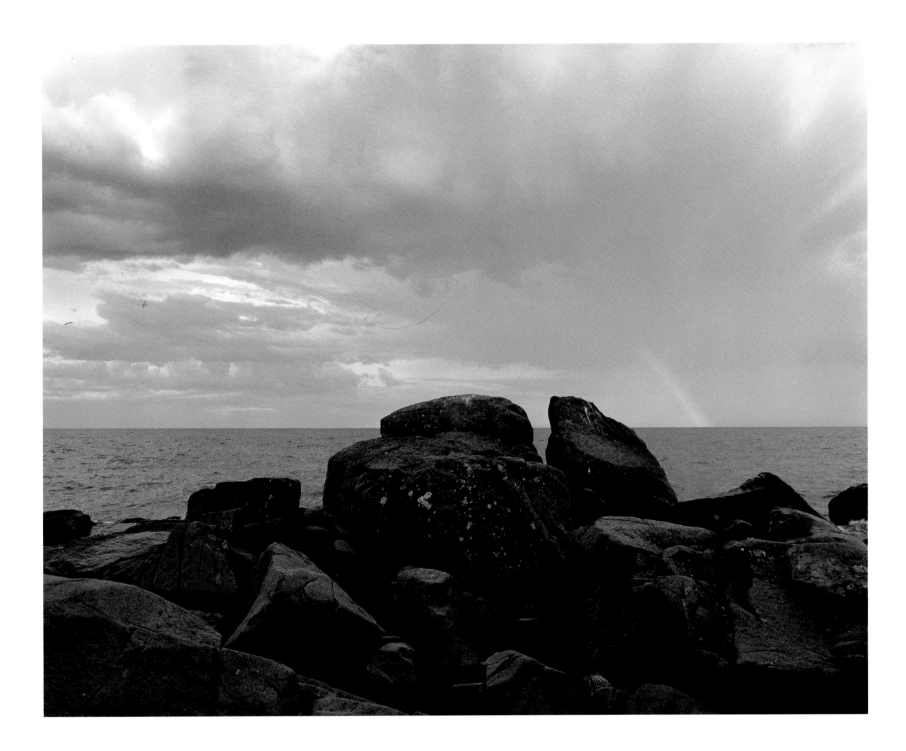

Kitchi Gammi Park (Brighton Beach)

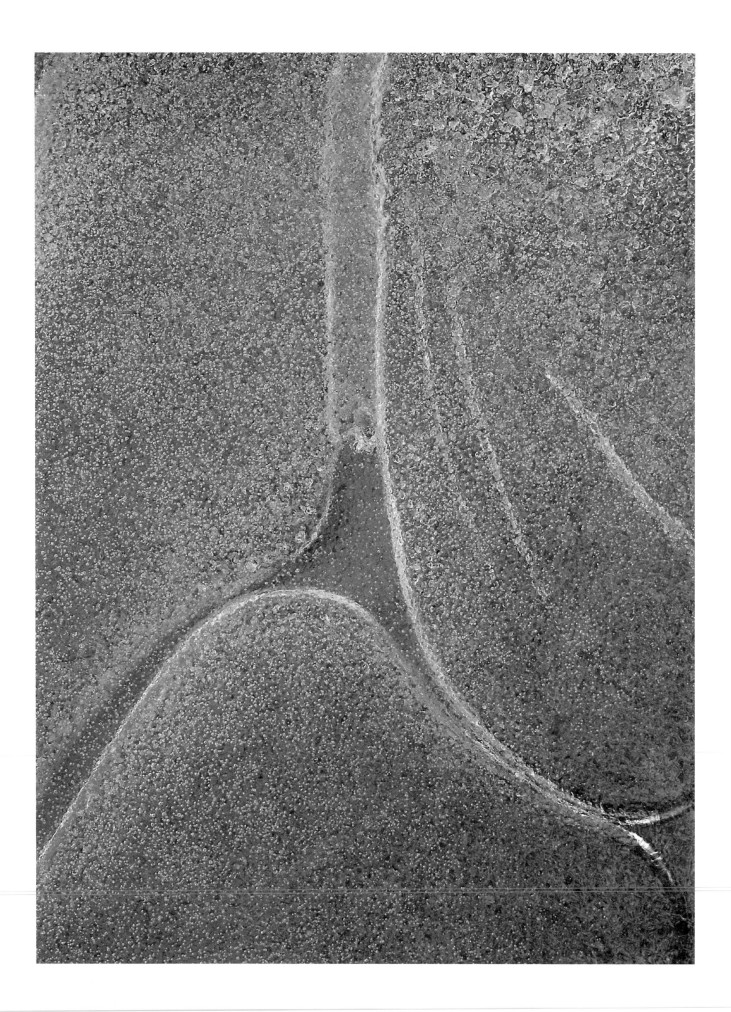

Close-up of ice, Kitchi Gammi

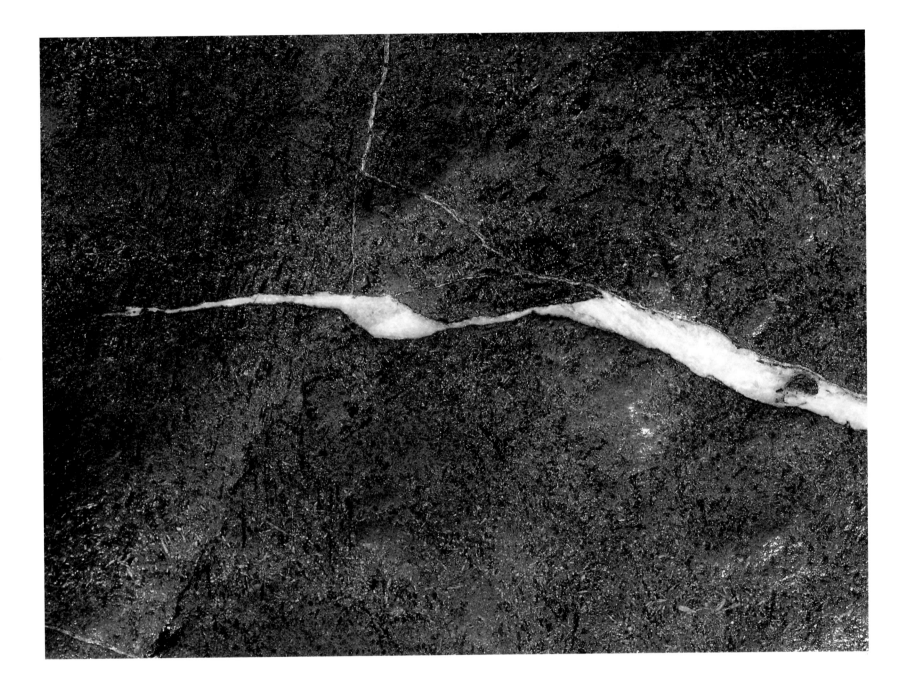

Calcite vein, Waterfront Park

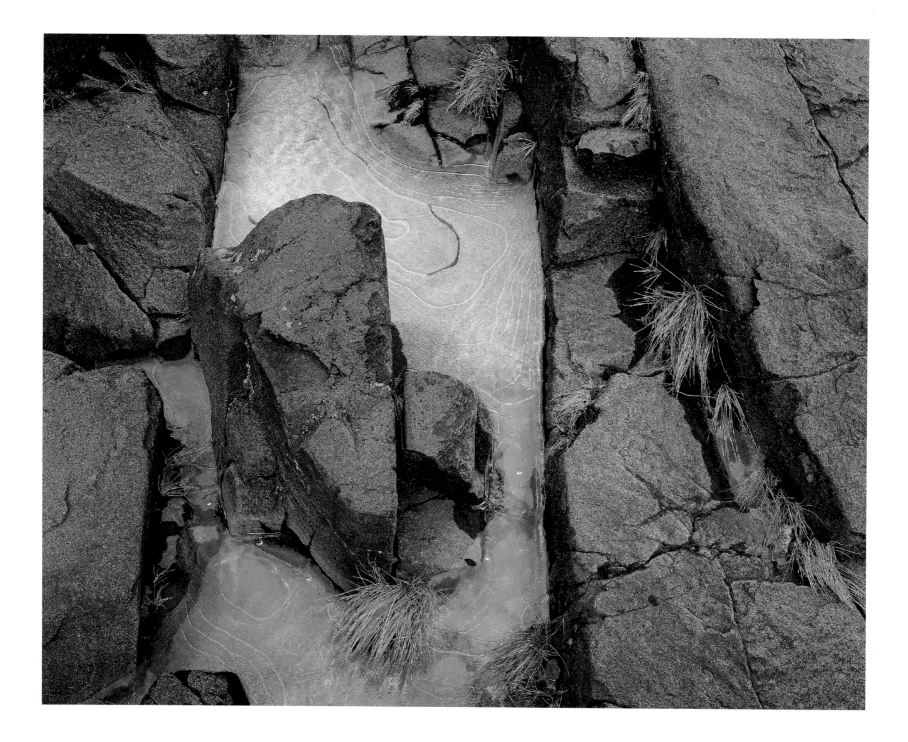

Frozen puddle, Kitchi Gammi Park (Brighton Beach)

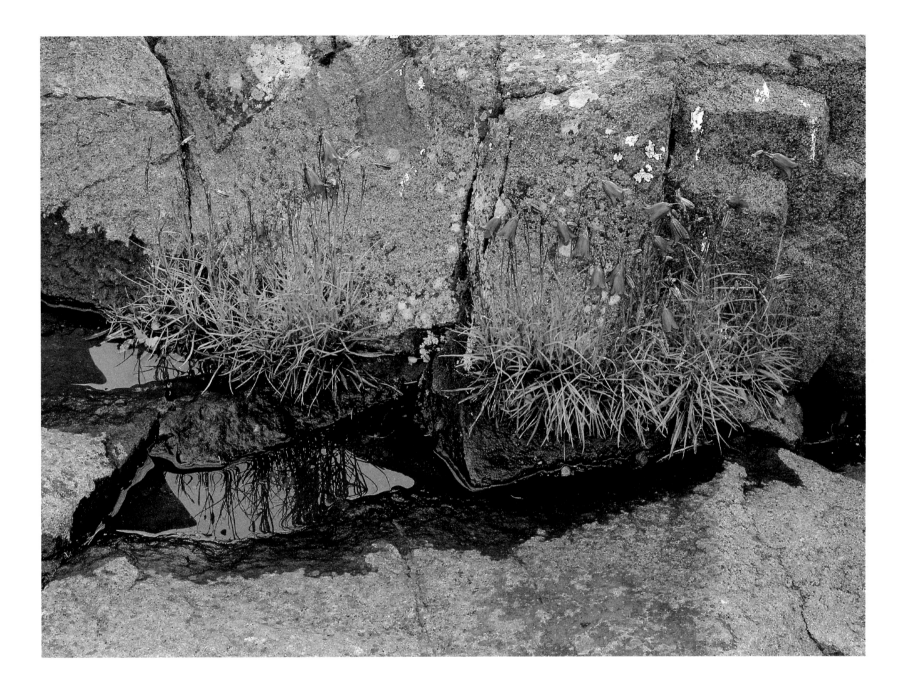

Harebells, Kitchi Gammi Park

It is 11 degrees below zero Fahrenheit at the water's edge; mild compared to the 30 below on top of the hill. Yet purple mists blown on exposed fingers feel like liquid nitrogen. I compose the image by placing the camera so a small sea stack is set against swirling fog and ice sheets, then wait for the glow of sunrise.

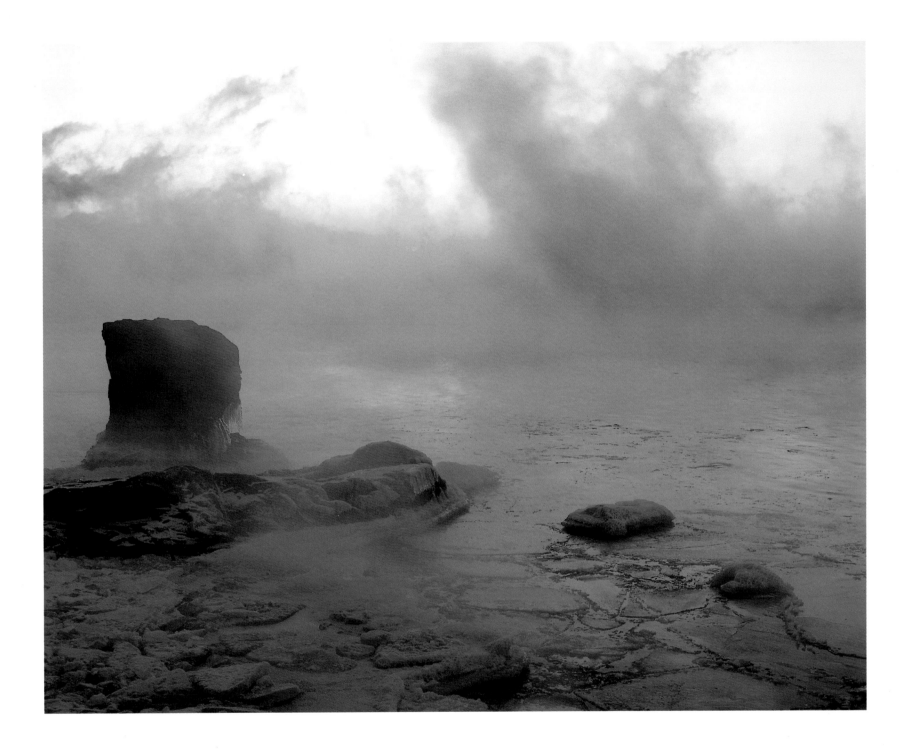

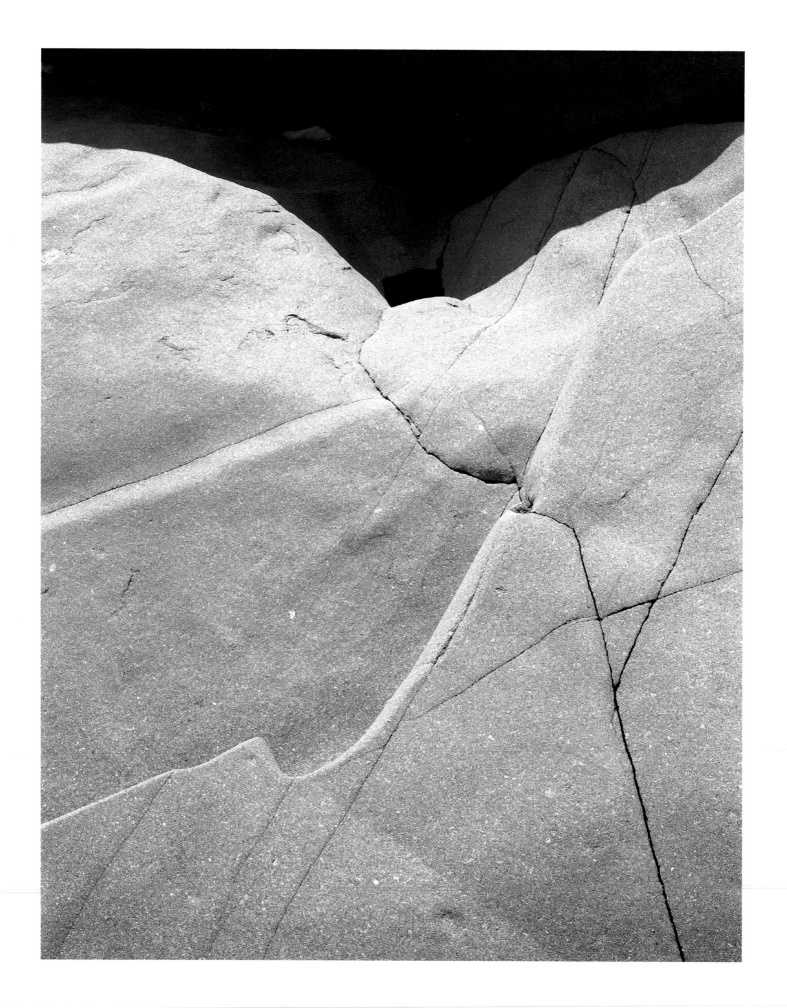

Cracks in diabase, Kitchi Gammi Park (Brighton Beach)

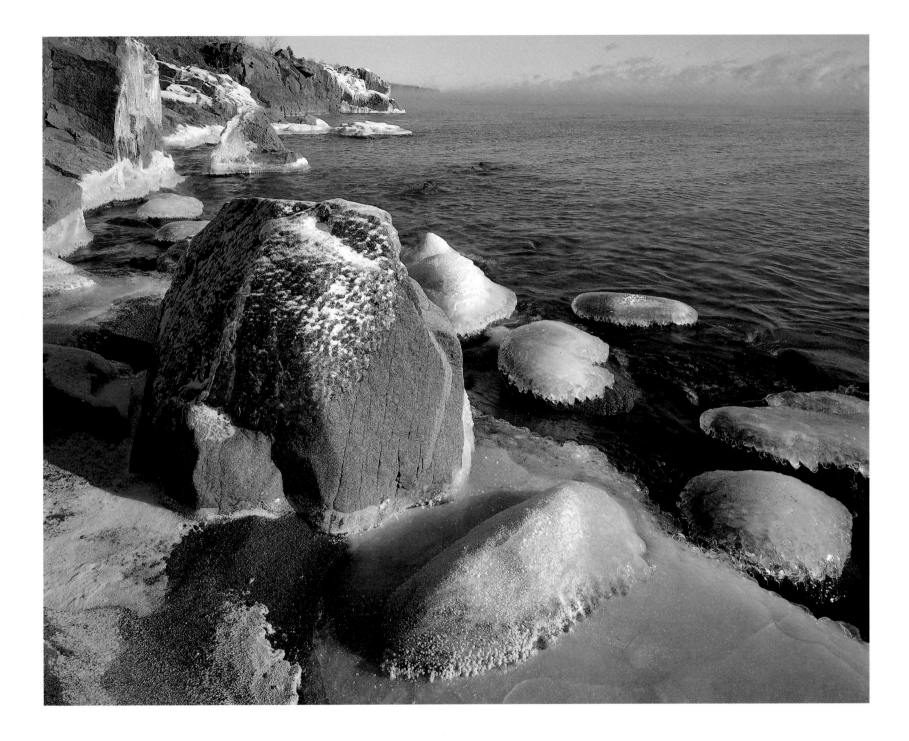

Lake Superior, Kitchi Gammi Park

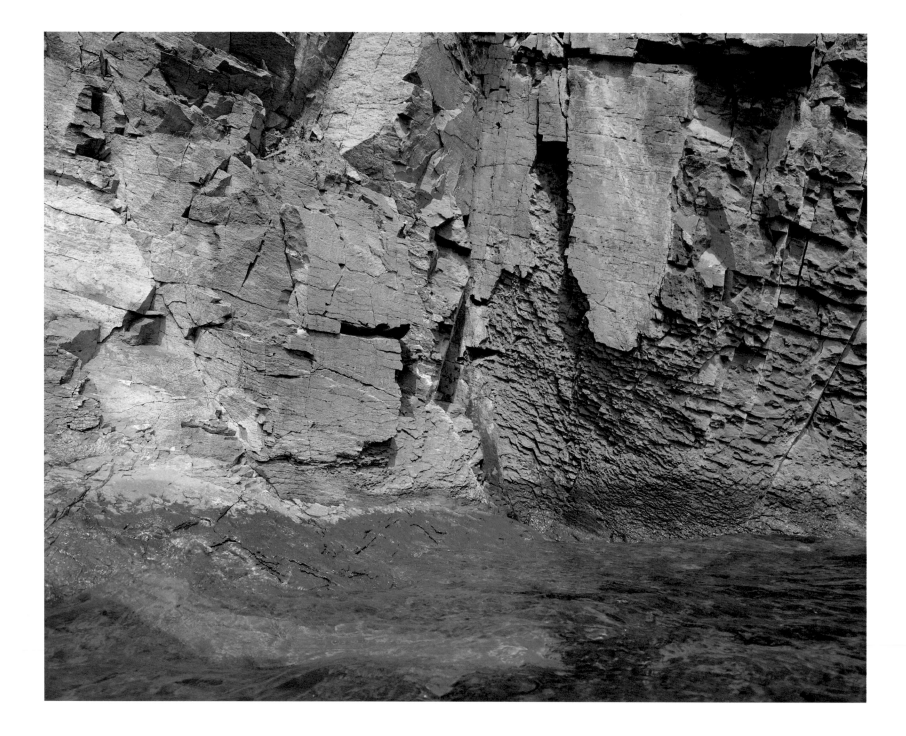

Rhyolite cliffs above Lake Superior

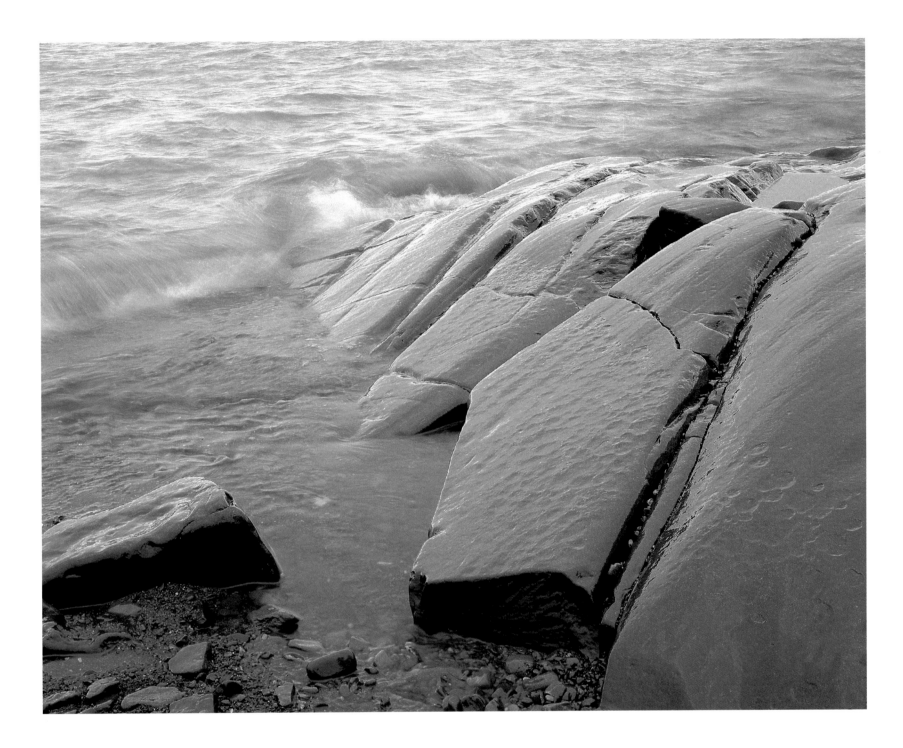

Basalt, Kitchi Gammi Park (Brighton Beach)

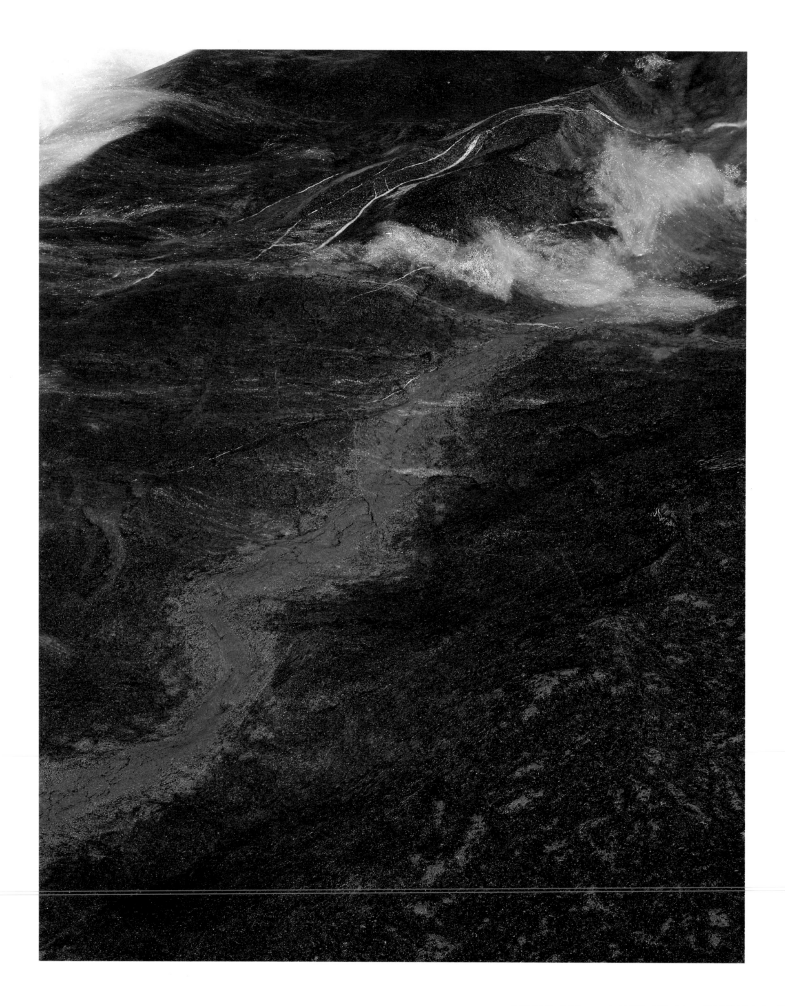

Granitic dike cutting diabase, The Ledges

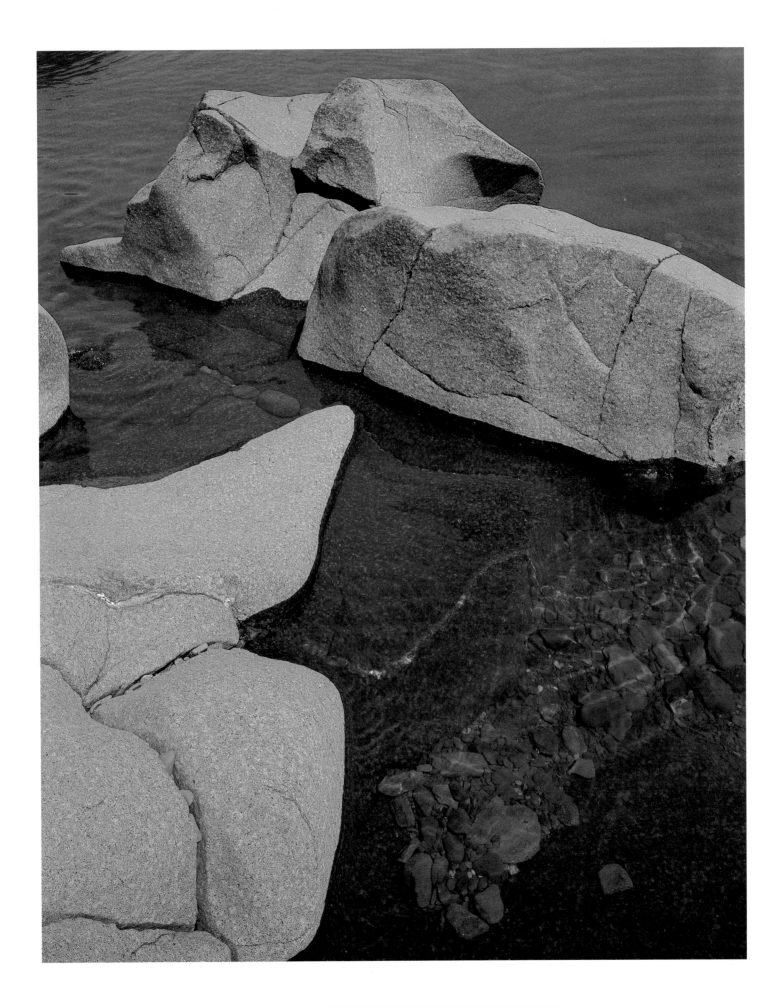

Lake Superior, Kitchi Gammi Park (Brighton Beach)

MINNESOTA POINT

Look down at Lake Superior from almost any hilltop in Duluth and your eyes are inevitably drawn to the sand beach leading to Wisconsin. Minnesota Point (commonly called Park Point) stretches out from Duluth's shore to almost touch Wisconsin Point. Together, these points form the longest freshwater sandbar in the world, creating a natural breakwater for the Twin Ports' shipping industry.

This sandbar is one of the region's most recent natural additions. According to one study, it began growing as a spit from the Wisconsin shore 3,200 years ago when the lake level dropped from 607 feet to 596 feet above sea level. As waves washed away fine particles of clay from the Wisconsin bluffs, the coarse sand mixed with it was left behind. Beach-drifting moved this sand towards Duluth, adding fifteen to twenty feet to the spit each year. The sand reached Minnesota's shore only a few hundred years ago, completing the bar. Sand washed down the St. Louis River, and harbor dredging spoils have also contributed to the bar. In 1871 the Duluth Ship Canal was cut through Minnesota Point, allowing ships a second entry point into the harbor. Harbor dredging, largely completed between 1873 and 1939, converted a shallow estuary into a port capable of receiving ocean-going vessels. Today, Minnesota and Wisconsin Points span nine miles, are an average of one hundred yards wide and fifteen yards deep, and have a volume of around twenty-three million cubic yards of sand!

Of course, what matters most to visitors is how good the sand feels between their toes. In a city with few natural lakes, Minnesota Point serves as the summer beach even though Lake Superior's waters are seldom warm enough for more than a quick dip. Minnesota Point is totally unlike any other place in Minnesota. Beach grasses and driftwood glow in low light; colors match the landscape—minimal, soothing. Midmorning sunlight flashes blindingly off the water and sand. Behind the beach, majestic red and white pines stabilize the dunes. Bird songs fill the forest in spring. Later in summer, acres of wild blueberries and raspberries are ready for picking. Beneath the trees the ground is covered with jigsaw pieces of red pine bark, fallen needles, cloudlike pillows of reindeer lichen—and thousands of glossy poison ivy plants.

Early on a still, foggy morning in June, we enter the forest with our cameras, hoping to make photographs before the rising sun erases the fog and stirs the wind. We walk through luminous openings filled with shinleaf and wild roses. White bunchberry flowers are strewn in drifts beneath the pines; tiny, pale-pink twinflowers dot the ground. With the woods to ourselves, we revel in the quiet dawn, speaking only when we want to show each other images we find. Later, walking back on the beach, we meet several joggers and their dogs. The morning is no longer quiet, but the sounds are happy ones. —NB

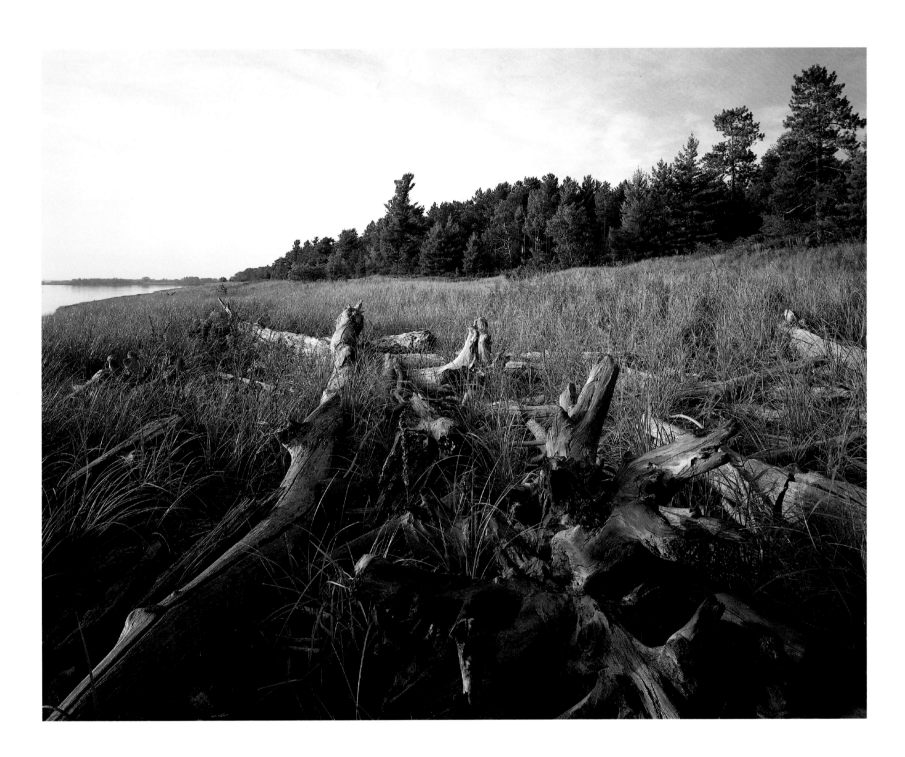

Driftwood, Minnesota Point Forest

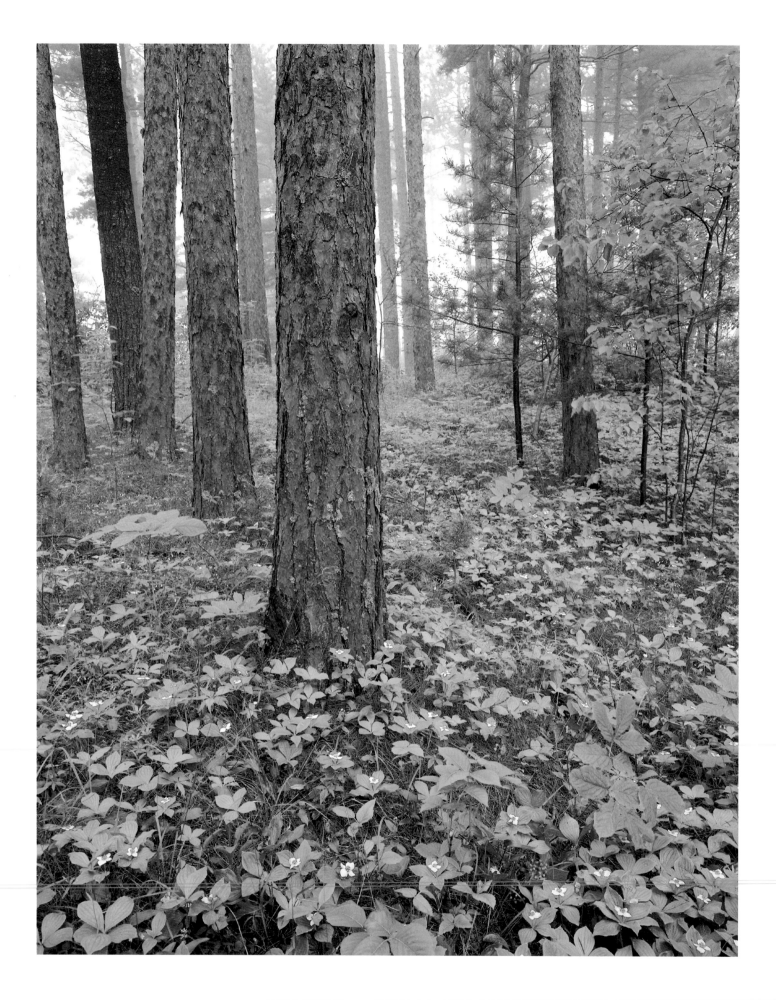

Red pines and bunchberry flowers, Minnesota Point Forest

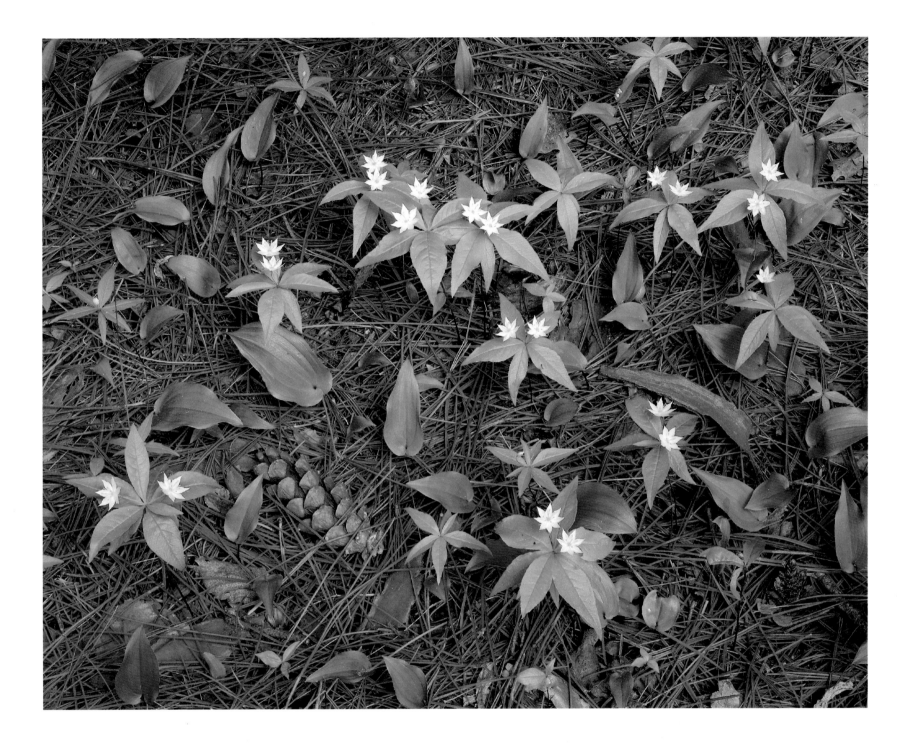

Starflowers, Minnesota Point Forest

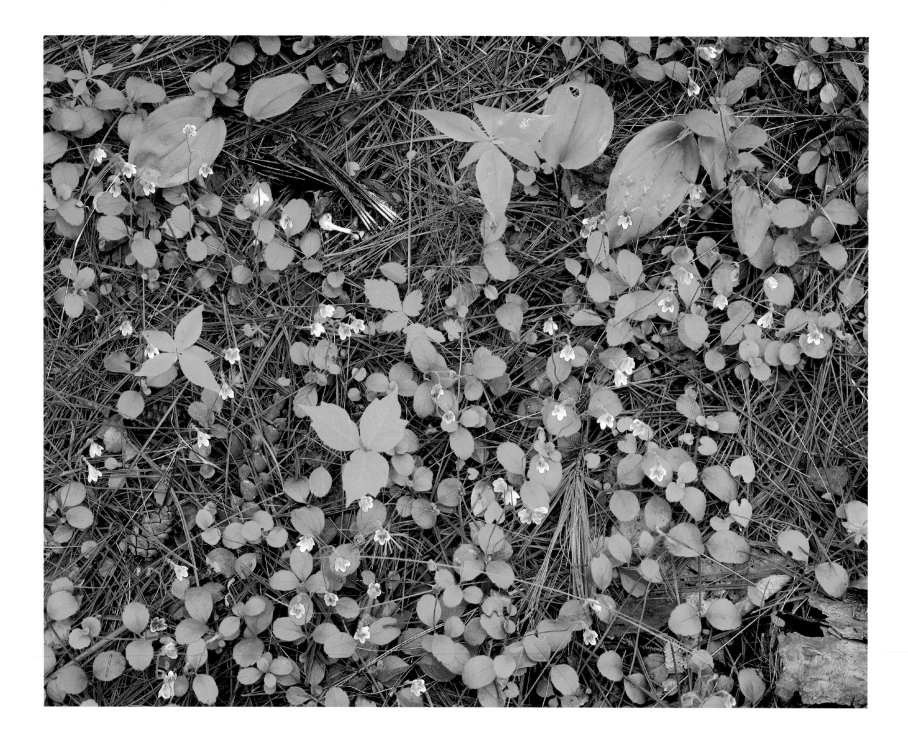

Twinflowers and bluejay wing, Minnesota Point Forest

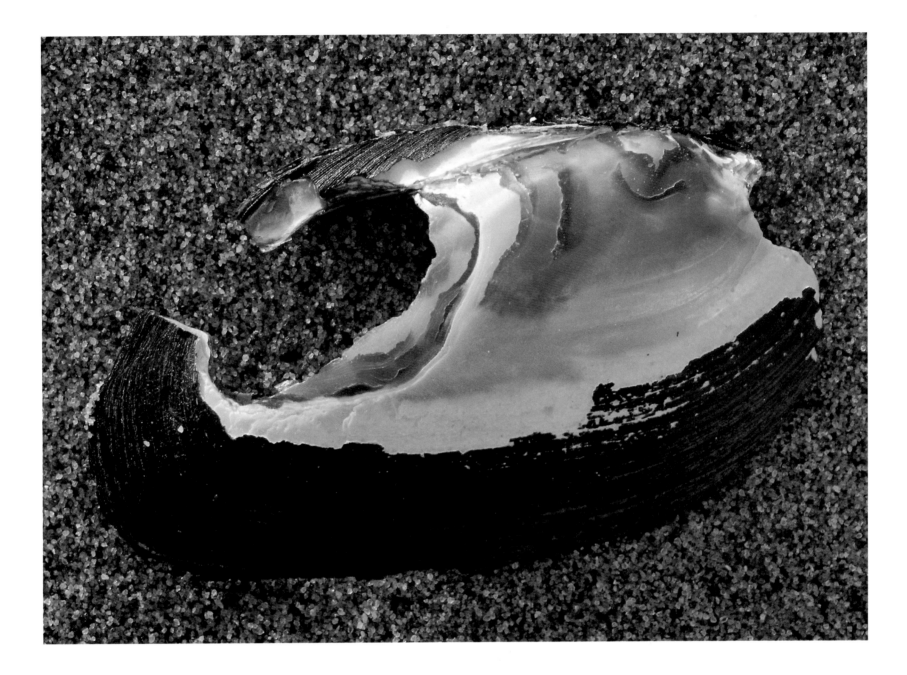

Clam shell, Minnesota Point

Duluth has elegant rose gardens, precisely designed and overflowing in colors. I found a different, equally elegant profusion of wild roses growing untended on Minnesota Point. Drawn first by the sheer mass and size of the bushes, I examined all the blossoms, finally finding what to me was the essence, a few petals settled on the warm sand.

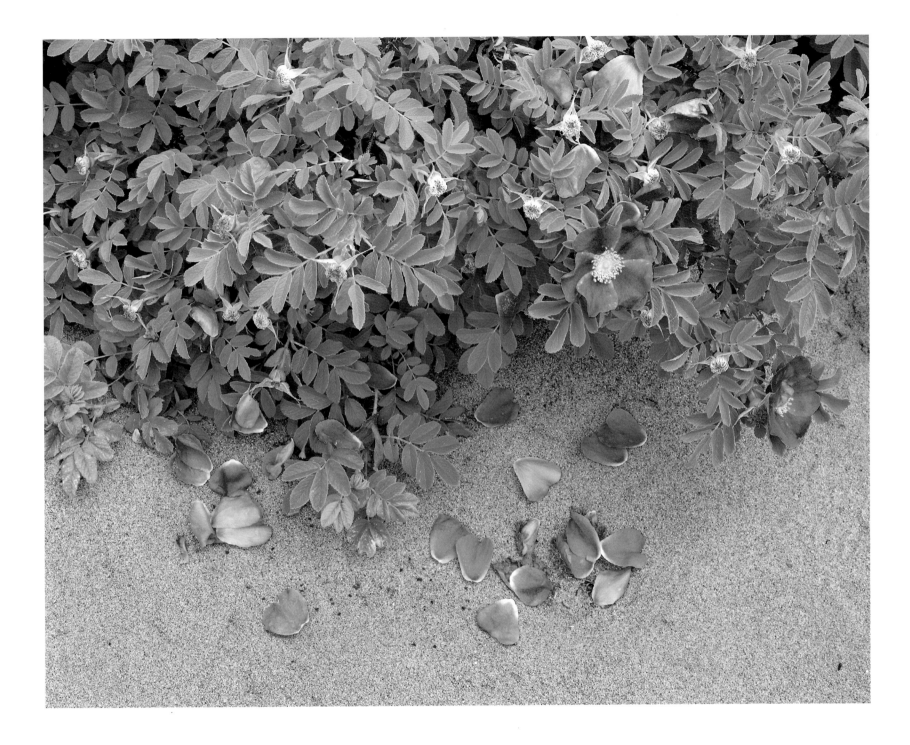

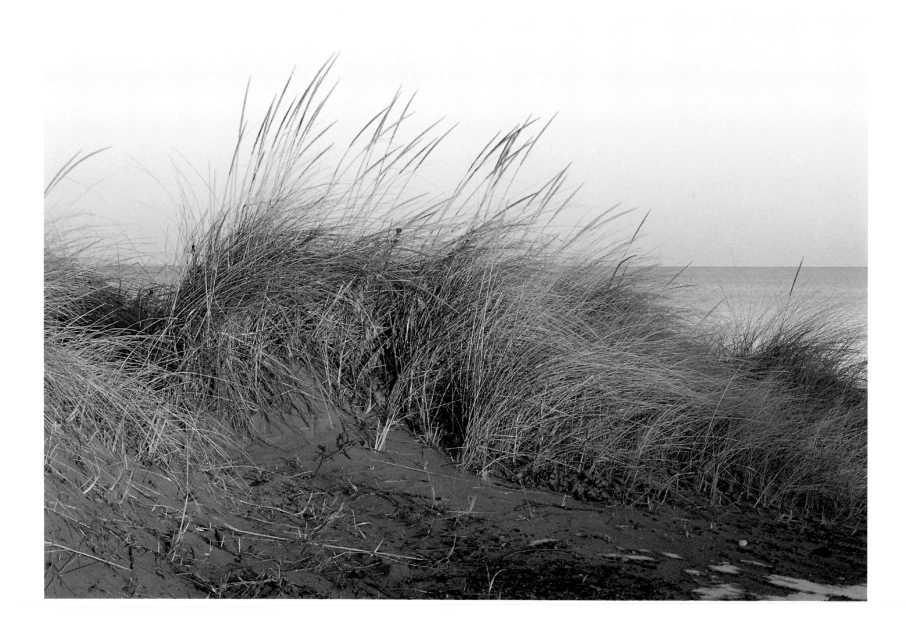

Beach grasses and Lake Superior, Minnesota Point

British soldiers and driftwood, Minnesota Point Forest

Like all beaches, Minnesota Point's sands collect litter from both land and sea. We've seen swash marks shimmering with the wings of thousands of butterflys and moths that died over the lake. Driftwood logs are strewn throughout the dunes. Occasionally a dead fish or bird washes up and is quickly recycled into the food chain. This photograph was made in the fall, when drifts of white pine needles catch gull feathers blown along the sand.

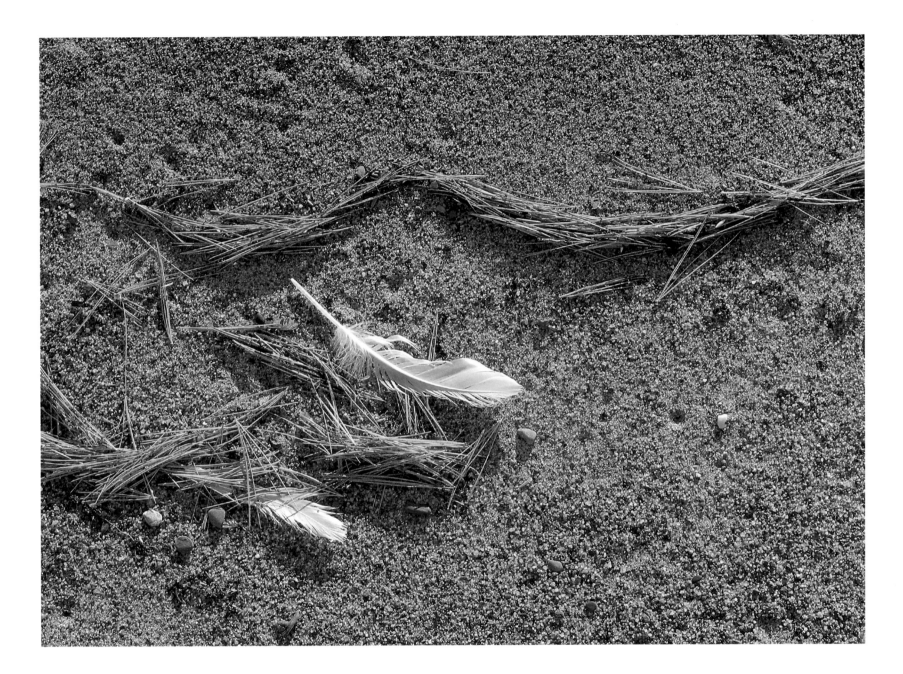

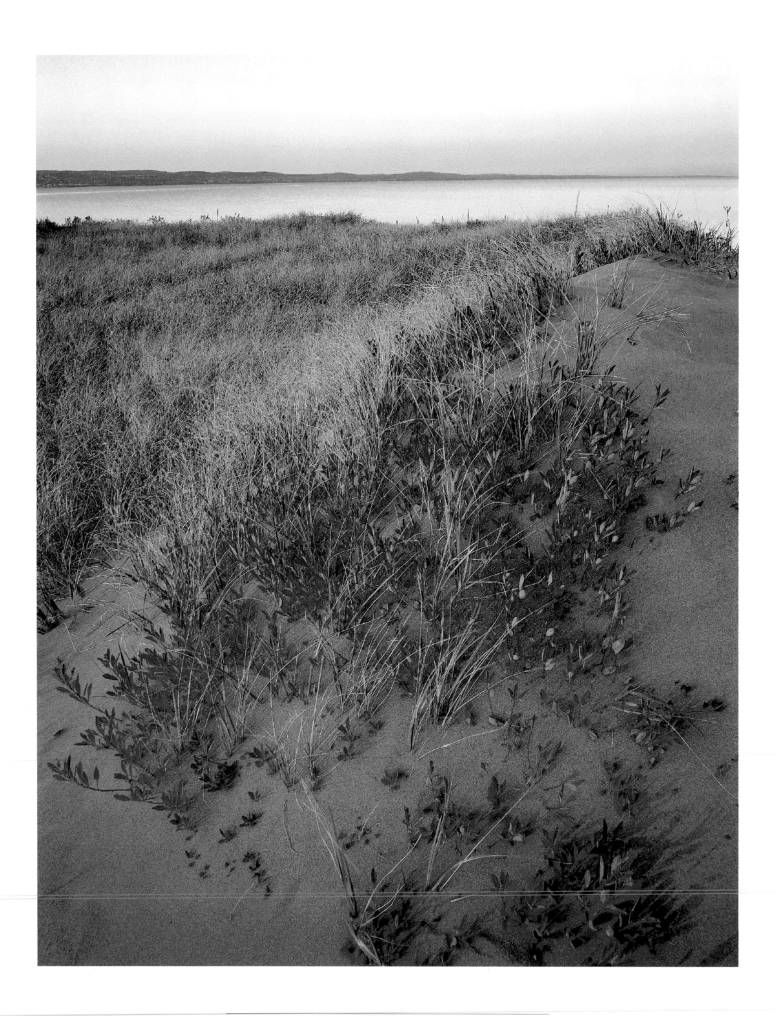

Dunes and Lake Superior, Park Point Recreation Area

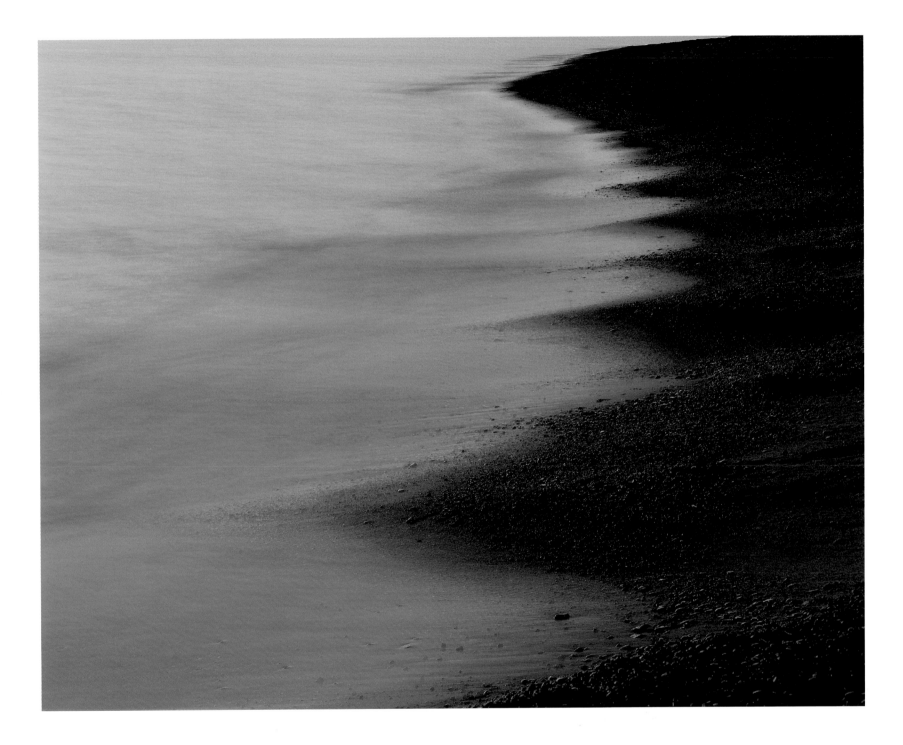

Predawn, Lake Superior, Park Point Recreation Area

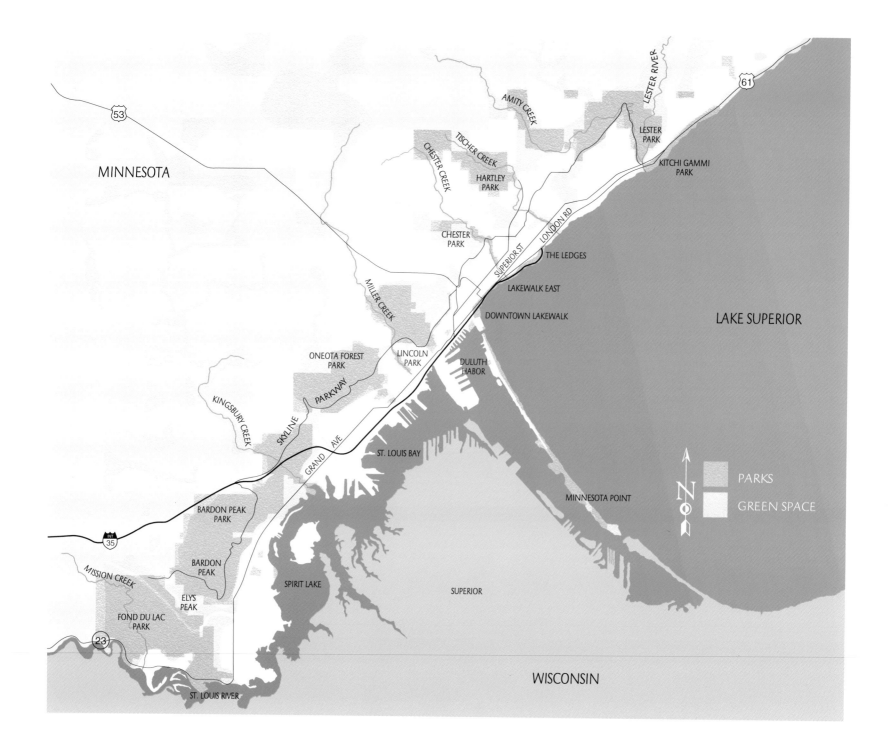

MINNESOTA

LAKE SUPERIOR

WISCONSIN

AMITY CREEK

LESTER RIVER

LESTER PARK

KITCHI GAMMI PARK

TISCHER CREEK

CHESTER CREEK

HARTLEY PARK

CHESTER PARK

THE LEDGES

LAKEWALK EAST

DOWNTOWN LAKEWALK

SUPERIOR ST.

LONDON RD.

MILLER CREEK

ONEOTA FOREST PARK

LINCOLN PARK

DULUTH HABOR

PARKWAY

KINGSBURY CREEK

SKYLINE

GRAND AVE.

ST. LOUIS BAY

MINNESOTA POINT

BARDON PEAK PARK

BARDON PEAK

SPIRIT LAKE

SUPERIOR

MISSION CREEK

ELY'S PEAK

FOND DU LAC PARK

ST. LOUIS RIVER

N

PARKS

GREEN SPACE

Parks and green spaces of Duluth

PHOTOGRAPHERS' NOTES

We first photographed Duluth in the early nineteen-seventies as students at the University of Minnesota-Duluth. Favorite areas in which to work were Bagley Nature Area, Kitchi Gammi Park, Minnesota Point, and Chester and Tischer Creeks. More recently, we have taken our photography workshop participants to these same locations, learning a bit more every year about the nature of the city. Even so, we were delightfully surprised by all the new things and places we discovered as we worked on this book. Each trip whetted our appetite for more.

The search for photographs is, for us, a mix of planning and serendipity. We research a composition, then wait for the light and time to be right. While waiting, we examine what's near us, and serendipity comes into play. We almost always find something unexpected that compels us to photograph it, too. Often, these things are small components of the landscape: a leaf caught in a curl of birch bark, a crack in bedrock, a shell fragment on sand.

We work primarily with 4x5 inch view cameras, using lenses from 75 to 300mm. When circumstances prohibit the use of the large-format cameras, we use either a Pentax 6x7cm camera with a 55mm lens, or a Nikkormat 35mm camera with 55 or 105mm macro lenses. Except when photographing from a kayak, the cameras are mounted on Bogen 3021 tripods with 3028 heads. A Pentax one-degree spot meter is used with the Zone System to figure exposures. A few 4x5 photographs were made on Polaroid Professional Chrome, a film no longer available. All others were exposed on Fujichrome Velvia, a transparency film with an ISO of 50. The majority of the film processing was done in Duluth by Custom Photo Lab.

As our book deadline approached, we knew we hadn't come close to hiking all the trails, climbing all the outcrops, or paddling all the shorelines. What we offer in this selection of images is, therefore, a mere sampling of what the city holds.

We hope these photographs refresh memories and lead you down new trails.